POSTCARD HISTORY SERIES

Along Virginia's Route 15

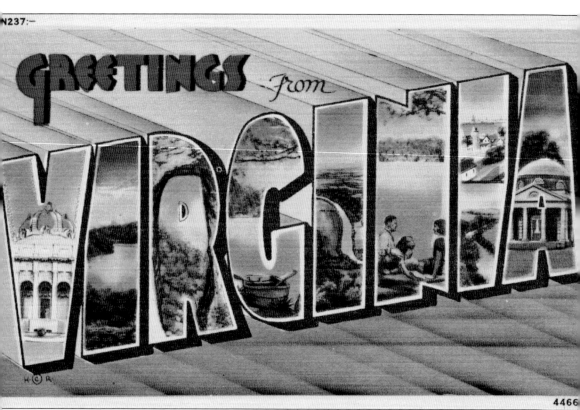

4466

In the first half of the 20th century, Virginia benefited from increasing numbers of tourists coming to visit historic sites and events like the 1907 Jamestown Exposition, the anniversaries associated with the American Civil War, the bicentennial commemorations of the births of George Washington and Thomas Jefferson, and the establishment of the Shenandoah National Park. This "Greetings from" postcard could be found in many souvenir shops throughout the commonwealth. (Author's collection.)

ON THE FRONT COVER: This postcard was produced in Culpeper by Bruce's Drug Store (to the right on Davis Street) and was probably sold inside the store. The Lerner's Department Store sign is visible farther down Davis Street on the right. Messinger and Company stands opposite Bruce's with a shoe sign in front. There are other signs for Standard Motor Oil, Florsheim Shoes, and Dolan's Billiards. In the center of the intersection in the foreground is what appears to be a traffic control device. (Author's collection.)

ON THE BACK COVER: Evergreen Lodge (also known as Greenway Farm) is located just south of Leesburg on U.S. Route 15. This view actually shows the rear of the house. Today housing developments close in on the home on three sides, but the pond still remains. (Author's collection.)

POSTCARD HISTORY SERIES

Along Virginia's Route 15

Josie Ballato

ARCADIA
PUBLISHING

Published by Arcadia Publishing
Charleston, South Carolina

Printed in the United States of America

Library of Congress Catalog Card Number: 2008929014

For all general information contact Arcadia Publishing at:
Telephone 843-853-2070
Fax 843-853-0044
E-mail sales@arcadiapublishing.com
For customer service and orders:
Toll-Free 1-888-313-2665

Visit us on the Internet at www.arcadiapublishing.com

To my parents, who taught me the lifelong lesson that all history is local.

CONTENTS

Acknowledgments

Postcards are ephemeral things. You mail them, someone receives them, and often they are then just thrown away. They were never intended to be kept; they were just meant to provide an easy way to let others know that they were on your mind while you were traveling across the countryside. Certainly, the idea that they might be kept for 50 or even 100 years would not have occurred to anyone except perhaps a pack rat. Thank goodness for pack rats, though! Without them, we would not have many of these images that give us insight into life in the Piedmont 50 to 100 years ago.

I want to thank the folks at the Journey through Hallowed Ground, who have worked so diligently to call attention to the U.S. Route 15–Route 231 corridor from Gettysburg, Pennsylvania, to Charlottesville, Virginia. In large measure, this organization is directly responsible for this region being designated a National Heritage Area. I also would like to acknowledge the important work of the Civil War Preservation Trust and the Piedmont Environmental Council. While they have different missions, the unifying theme between these organizations is that they diligently work to preserve the heritage and natural beauty of the Piedmont area.

I would like to call attention to the excellent local libraries in the region. Of particular note are the Thomas Balch Library in Leesburg and the always exceptional Culpeper County Library in Culpeper. Please continue to support your local library and its local history room, no matter where you live.

During the time I was researching these postcards, by happenstance, my path crossed with two women who provided me with clues to answer questions about mystery postcard locations I had been unable to solve. One was K. D. Kidder of Photoworks in Leesburg, and the other was Marcia Markey of Grace Episcopal Church in The Plains. Thank you so much for taking the time to help.

Finally, thanks most of all to Laurie. Without your companionship during the road trips to search out these postcard locations, those adventures would not have been nearly as enjoyable. You have helped so much during this entire project that my appreciation is boundless.

INTRODUCTION

Postcards may be the least utilized resource in historical research. Perhaps this should not be surprising because they only came into widespread use after 1900, and few have been published since the 1970s. Postcards were not viewed as historically significant but often were just cheap souvenirs of places visited or merely a simple way for someone to stay in touch when either paper or time did not permit a lengthier letter.

These postcards are from my personal collection, and it was not until I began to find multiple images of the same locations, taken at different times, that I began to realize what a rich resource they were for uncovering an area's local history. Particularly, and perhaps obviously, they showed how towns and travelers' experiences evolved. This collection does include a few postcards of private homes, but for the most part, the views are of what everyday travelers from 1900 to 1940 would see as they passed through the northern Piedmont region of Virginia by wagon, passenger rail, or automobile.

In 2008, Congress designated the region from Gettysburg, Pennsylvania, to Charlottesville, Virginia, as a National Heritage Area. Different in mission from a national park, a national heritage area is a way to recognize a region's historic or natural significance that contributes to some aspect of the nation's history or identity. U.S. Route 15 and Route 231 traverse an area unsurpassed in importance to the nation's founding and preservation.

Because the scope of this book covers multiple towns and counties, selecting the order and organization of the material became a challenge. It is difficult to predict how a reader might wish to approach this material. Often books are organized by individual counties. However, people and geography do not always adhere neatly to county boundaries. Plus, many road maps often do not highlight counties but will focus instead on cities and towns. To bridge these two types of organizational approaches, I have chosen to identify the county seats of Loudoun, Fauquier, Culpeper, and Orange Counties for the chapter headings. Within each chapter, I have tried generally to organize the postcards from locations north to south and west to east traveling down U.S. Route 15, starting from the Maryland border.

I also envision giving the reader an option to use this book either as a research resource or as a tour guide to the area. Hopefully, the captions will guide you to the location of the postcard's subject, so you can see for yourself how the landscape has either changed or, as is often the case, remained the same. One of the concepts behind the designation of a National Heritage Area is to highlight the culture and geography behind the history. This can serve to refocus our attention on more than just the biggest or most well-known people, places, or events. A heritage area can help us to relearn forgotten history or rediscover events that may have faded into the background over time because of evolving cultural focus or changing societal priorities. While Monticello and the large Civil War national battlefield parks are certainly important tourist destinations, and were the subject of many postcards, I have opted to select

images of what once was important to local communities—enough so that someone decided to publish a postcard about that place or event.

To assist in the learning about these subjects, I hope you will take this book on the road with you. It is fun and challenging to hold up an image and to try to determine which buildings still stand or what has been changed and why! With every postcard for which I was able to determine its location, I have tried to incorporate that information into the caption.

I hope you find these postcard images as interesting as I have. We take for granted something we see everyday, and when it is gone, we may not realize what we now miss. These postcards may give you a new perspective on, or will serve as a reminder of, what you may already know. Hopefully, dusting off these memories will ignite a renewed passion for honoring and preserving our history, as well as serving to create a foundation for preserving this history for our future.

One

LEESBURG
(LOUDOUN COUNTY)
AND VICINITY

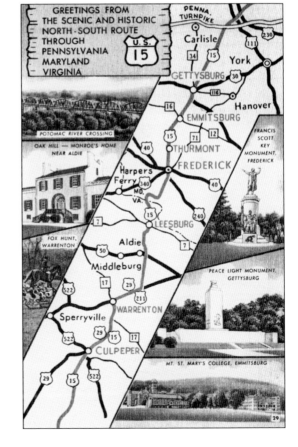

Beginning the journey along Route 15 traveling southward toward Leesburg, one will cross the Potomac River into Virginia. Traversing Loudoun County, land of former U.S. president James Monroe and Gen. Billy Mitchell, fellow travelers from bygone days sent these postcards from the towns and villages of Waterford, Bluemont, Lincoln, Purcellville, Leesburg, Aldie, and Middleburg.

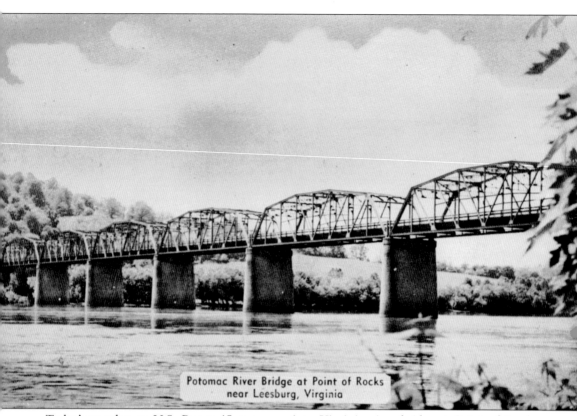

Potomac River Bridge at Point of Rocks
near Leesburg, Virginia

Today's traveler on U.S. Route 15 can cross into Virginia via a bridge at Point of Rocks, Maryland, which was constructed in 1937. Known as a camelback truss bridge, this is an eight-span steel truss structure. It is approximately 48 miles upriver from Georgetown and is the only bridge crossing of the Potomac River for almost 40 miles after leaving the Washington, D.C., beltway.

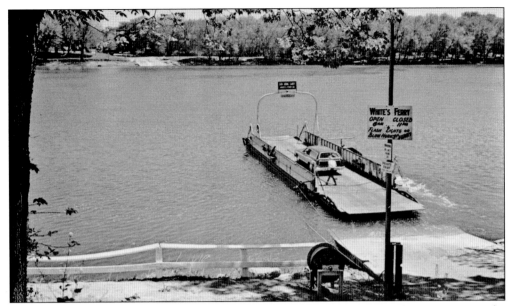

On its way to Antietam in Maryland, the Confederate army crossed the Potomac in the area of White's Ford, near Leesburg. Now the river can be crossed by ferry at White's Ferry. Generally, vehicle ferries are a thing of the past, but White's Ferry is an active and essential means of crossing the Potomac River. Many commuters use this cable-driven, multi-vehicle barge every day, and travelers along Route 15 can take a side trip to experience this river crossing between states.

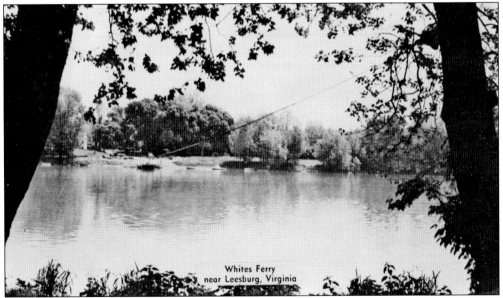

The White's Ferry cable across the Potomac can be seen in this postcard from the 1930s or 1940s. The view appears to be looking toward the Maryland side of the Potomac. The ferry's name changed from Conrad's to White's soon after the Civil War's end. A warehouse-granary once operated here to fill Chesapeake and Ohio (C&O) canal boats with grain destined for markets near Georgetown and Washington, D.C. White's Ferry is located 40 miles northwest of Georgetown along the C&O Canal towpath.

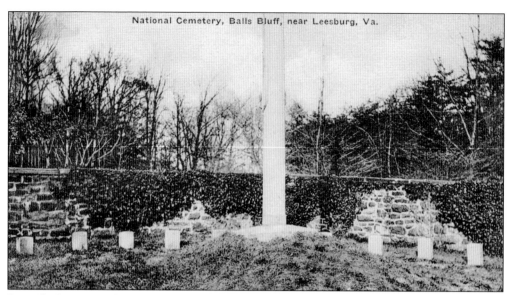

National Cemetery, Balls Bluff, near Leesburg, Va.

Described as situated "[a]mong the rugged and precipitous river hills" of Loudoun County in the National Register of Historic Place's records, this quiet resting place for 54 Union soldiers, killed in October 1861 at the Battle of Ball's Bluff, is one of the country's smallest national cemeteries. One of those killed in the fight was former U.S. senator "Ned" Baker, a friend of Abraham Lincoln, who named his son Ned in honor of Baker. Colonel Baker's body was removed from the battlefield and was later buried in California. This cemetery is located a few miles north of Leesburg.

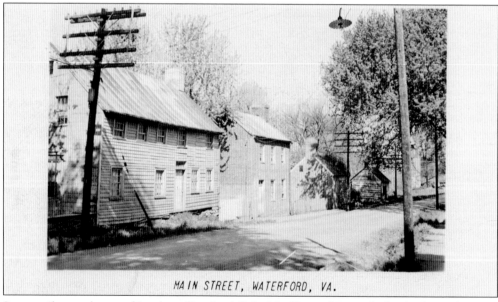

MAIN STREET, WATERFORD, VA.

Seven miles northwest of Leesburg lies the delightful village of Waterford, which was founded as a Quaker village around 1730. As is so aptly summarized on the nomination form for the Historic Register, "the mill town of Waterford remains virtually unchanged from its eighteenth and nineteenth century appearance. A major factor in Waterford's character is the unspoiled open rolling landscape which surrounds the village and enhances its integrity." The town continues to fight to retain its historic character despite pressures from nearby land development.

If not for the foresight of the Waterford Foundation, much of the historic flavor of this area might have been lost over the years. The village of Waterford is considered one of the best remaining examples of an early Quaker community to be found in the eastern United States. This postcard may have been published as a souvenir for the Waterford Foundation in the 1940s.

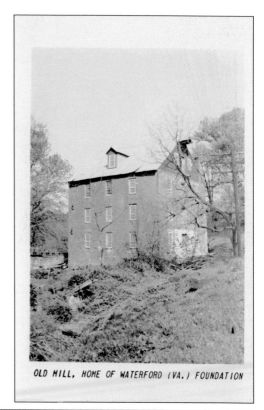

OLD MILL, HOME OF WATERFORD (VA.) FOUNDATION

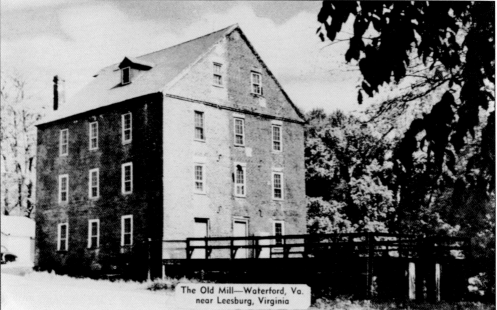

The Old Mill—Waterford, Va.
near Leesburg, Virginia

Waterford was a mill town from its earliest days—so much so that its original name was Milltown. This mill is believed to be the third one constructed at this site and was built around 1830. What makes this an especially significant structure is that this commercial building survived the trials and tribulations of the Civil War and continued to operate into the 1930s.

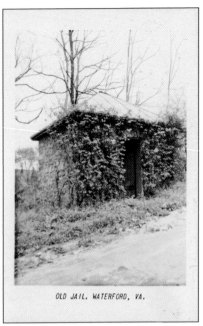

OLD JAIL, WATERFORD, VA.

As befitting a Quaker community, the Waterford jail in this view, perhaps from the 1940s, appears small and infrequently employed. The stone jail has a pyramid-shaped roof and was intended to hold transgressors for short periods before either their release or transfer to another county facility.

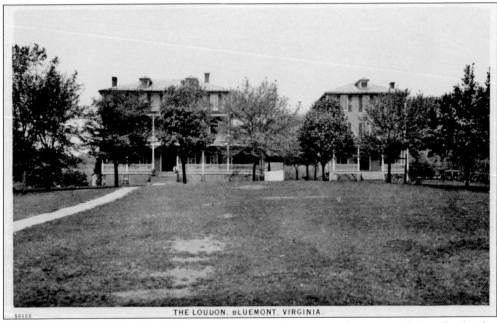

THE LOUDON, BLUEMONT, VIRGINIA.

The Loudoun Hotel of Elizabeth Avenue was one of a variety of accommodations built after 1900 in the small village of Bluemont in the higher elevations of western Loudoun County. Prior to the railroad making the village a destination point, Bluemont had been known as Snicker's Gap or Snickersville. Railroad managers thought a name like Bluemont was a more appealing name for a mountain resort destination that they planned for vacationers looking to escape hot summers. The plan succeeded for about 30 years, and places like the Loudoun Hotel hosted many guests. However, the advent of the automobile and the Great Depression ended train travel to Bluemont. Today several structures, like the Loudoun Hotel, form the heart of the Bluemont Historic District, located off Route 7 and Route 760.

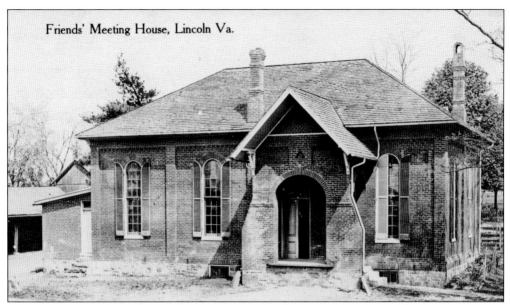

Friends' Meeting House, Lincoln Va.

The Quakers established several settlements in Loudoun County, one being on the banks of Goose Creek. In the 1750s, because of the church located there, the community became known as Goose Creek. In 1861, when a U.S. post office was approved, the community name was changed to Lincoln to honor the newly elected president. The Goose Creek Historic District is listed on the National Historic Register, and the community of Lincoln is located south of Purcellville at the intersection of County Roads 709 and 722.

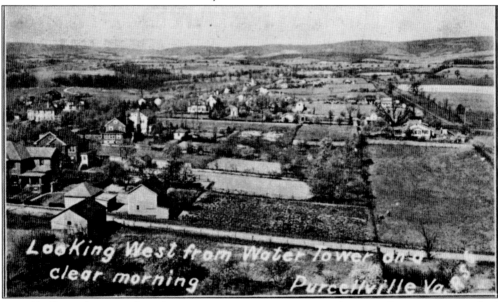

Looking West from Water Tower on a clear morning. Purcellville Va.

Purcellville, to the west of Leesburg on Route 7, was incorporated in 1908, but a community had been located here since the 1760s. The Purcell family operated the community's first store and post office. This image was probably made near the time of the town's incorporation. Looking west, the view is toward the Blue Ridge Mountains. Purcellville benefited from its proximity to the railroad. Later the line became the Washington and Old Dominion. The demise of the trains to Purcellville led to the use of the old railroad bed as an excellent bicycle trail.

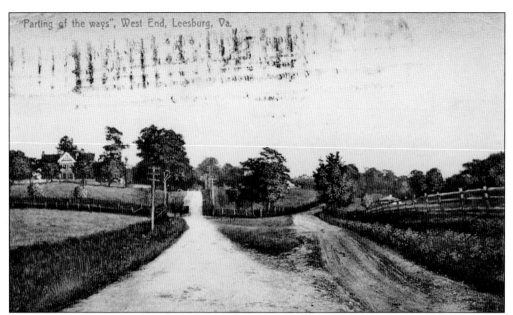

"Parting of the ways", West End, Leesburg, Va.

This postcard's publisher decided to add a humorous flourish by titling it "Parting of the Ways." The town of Leesburg was laid out with two major east-west streets, Market and Loudoun Streets, which rejoined on both the east and west sides of town. This is an early view of what the roads looked like on the west side of town. Imagine being a traveler heading east toward the nation's capital and coming upon this fork in the road. With no street signs to guide a newcomer, this would certainly be a spot to stop to ponder the options.

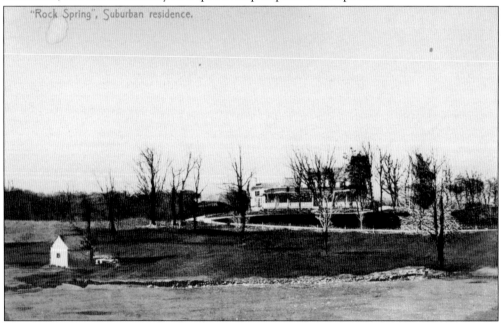

"Rock Spring", Suburban residence.

Not a remote farm, Rock Spring sits adjacent to the town of Leesburg just off Loudoun Street. Named for a spring located on-site, this home is listed on the National Register of Historic Places. The earliest part of the structure was built in the 1820s; this postcard image was made sometime in the early 1900s, prior to the addition of another wing to the home.

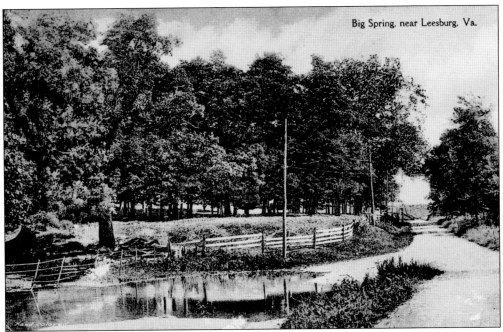

Since this postcard was mailed to Camp Humphreys, Virginia (later Fort Belvoir), it may have been sent to a World War I soldier. The author promises the recipient that he will have a good job on hand for him, perhaps when he returned to the Leesburg area. This may look like a back road, but it is most likely the road just north of Leesburg that became U.S. Route 15.

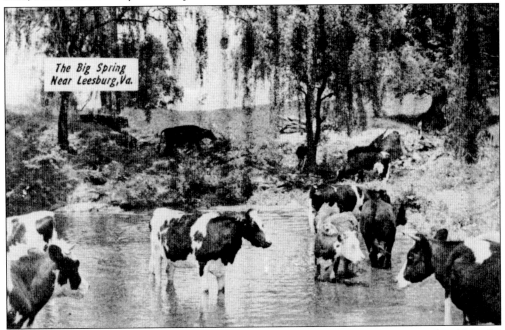

For reasons yet to be uncovered, the Big Spring was a favorite image for postcards sold in the Leesburg area. Perhaps the image of cows so close to town reinforced a humorous view of Southern backwardness. At one time, the Big Spring was described as originating 2.4 miles north of Leesburg from an underground stream a few feet from Route 15.

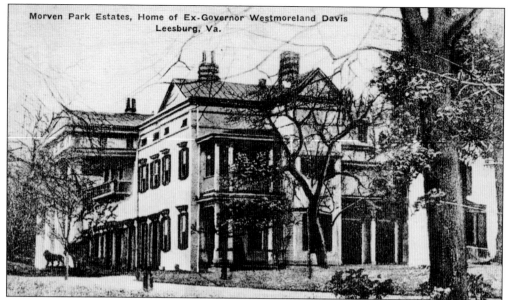

Morven Park Estates, Home of Ex-Governor Westmoreland Davis
Leesburg, Va.

Just west of historic downtown Leesburg is Morven Park, a grand estate dating back to the 1780s. It has undergone many renovations since its construction. Westmoreland Davis was one of its more famous occupants. He was governor from 1918 to 1922. As this postcard refers to him as ex-governor, the card dates to some time after 1922. This photograph is unusual because most views of the home are from the front lawn. This perspective is from the side of the house, with the front to the left. Governor Davis's widow established a foundation in his honor that resulted in this beautiful estate being opened to the public.

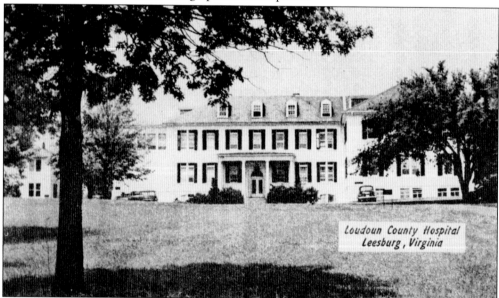

Loudoun County Hospital
Leesburg, Virginia

According to the *Loudoun Mirror* newspaper, the Loudoun County Hospital opened to serve Leesburg and the greater Loudoun County community during the Leesburg Horse Show, on June 5, 1912. At that time, the hospital did not have the wing shown to the right in this view. Loudoun County has built a newer hospital, and this building, located at 224-B Cornwall Street, now serves as the free clinic.

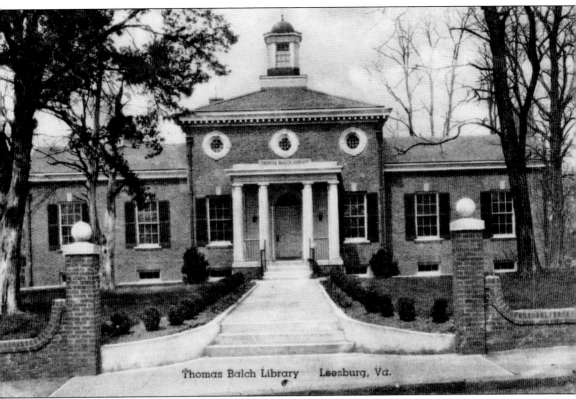

Thomas Balch Library Leesburg, Va.

Named for a pioneer in international arbitration, the Thomas Balch Library is located in the 200 block of West Market Street in Leesburg. The building was designed by Washington, D.C., architect Waddy Wood. Balch was born in Leesburg in 1821, and the library was dedicated 101 years after his birth. Thomas Willing (T. W.) Balch was both a historian interested in the American Revolution and a lawyer. His efforts to salvage diplomatic relations between the United States and Great Britain, which had been strained during the American Civil War, led to the use of a court of arbitration to settle a dispute over Great Britain's involvement in aiding the Confederacy during the Civil War.

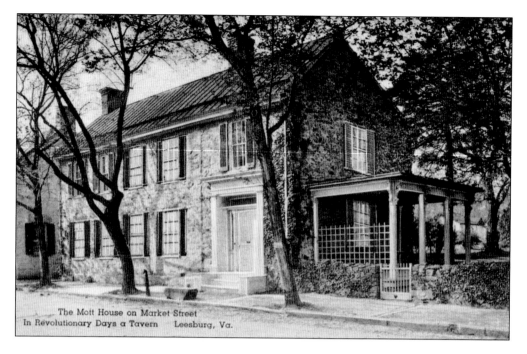

The Mott House on Market Street
In Revolutionary Days a Tavern Leesburg, Va.

An interesting stone building sits at 20 West Market Street. Known under various names, including the John Miller Ordinary, the Mott House, and the Laurel Brigade Inn, this building has long been a landmark in downtown Leesburg. The exterior is coursed rubble stone, and it was built in the 1760s as a tavern, or "ordinary," for travelers going east and west through Leesburg. The tavern can be seen from two different angles in these two postcards. The bottom view shows the surrounding street, with a theater across the street and King Street at the corner in the distance.

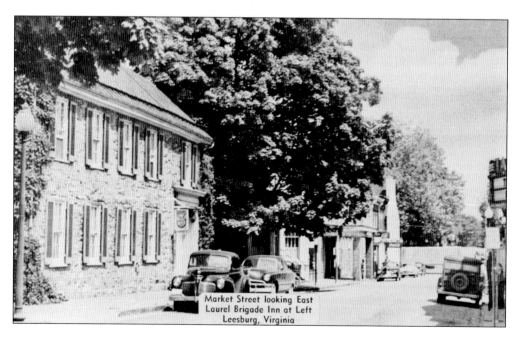

Market Street looking East
Laurel Brigade Inn at Left
Leesburg, Virginia

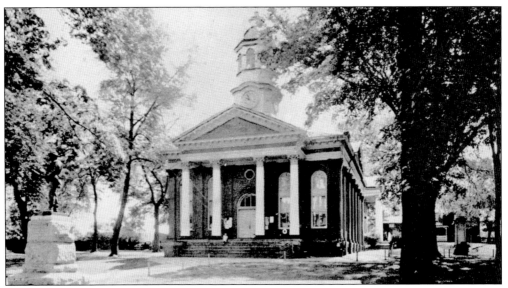

Leesburg is the Loudoun County seat. The courthouse square is in the midst of the town's historic district at the intersection of King and Market Streets. Richmond architect William C. West designed this courthouse, the third in the county's history. Construction began in 1894 with the laying of the cornerstone, which, according to local newspaper accounts, contains a lambskin apron, copies of local Masonic newspapers, a photograph of the 1811 courthouse (torn down to make way for the new building), an almanac, and U.S. and Japanese coins. Former U.S. president James Monroe served as justice of the peace in an earlier courthouse on this site during his retirement.

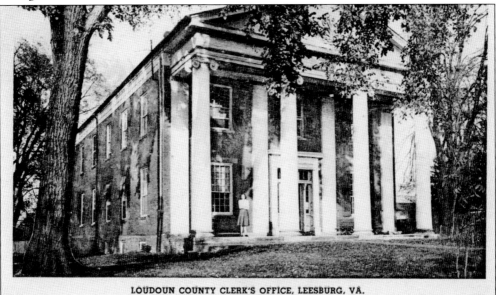

LOUDOUN COUNTY CLERK'S OFFICE, LEESBURG, VA.

This building adjacent to the Loudoun County Court House on Market Street appears to fit perfectly as a government office building. However, it was actually constructed as the Leesburg Academy for Boys in 1848. The school sold the building to Loudoun County in 1873, and it was converted into the county clerk's office. When the county required more office space in the late 1950s, an identical structure was built next door.

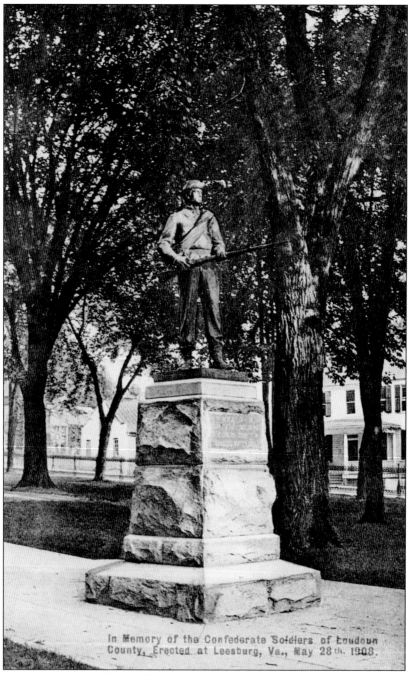

In Memory of the Confederate Soldiers of Loudoun County, Erected at Leesburg, Va., May 28th. 1908.

Located directly in front of the Loudoun County Court House in downtown Leesburg is the obligatory monument to Confederate soldiers found in many Southern towns. What makes this one so unusual is that the soldier is cast in bronze, which represents a larger financial commitment by the community. Erected on May 28, 1908, the statute was designed by Frederick William Sievers. After handling Loudoun County's commission, Sievers went on to create other major monuments at the Gettysburg Battlefield and along Richmond's famed Monument Avenue.

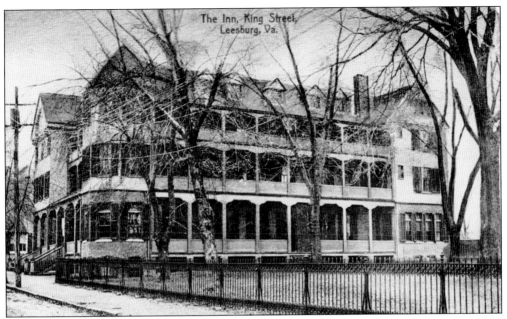

The Inn, King Street,
Leesburg, Va.

Next to Loudoun County's courthouse in downtown Leesburg, the Leesburg Inn served as a hotel for many years for traffic passing through the town on King and Market Streets. In the early 1950s, the county bought the inn to use for additional space for county offices, but by the 1970s, Loudoun County decided to tear it down to make way for a new county administration building. This is how the inn on King Street appeared around 1916.

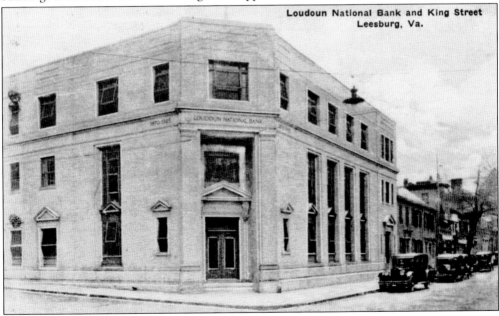

Loudoun National Bank and King Street
Leesburg, Va.

The Loudoun National Bank occupied prime real estate at the corner of Market and King Streets in the heart of Leesburg. Chiseled next to the bank's name are the years 1870–1925, so it is safe to say this is a post-1925 postcard. Visible in the upper portion of the building are the wires that crisscrossed the street and supported the streetlights that hung across the intersections of many towns in the Piedmont area at this time.

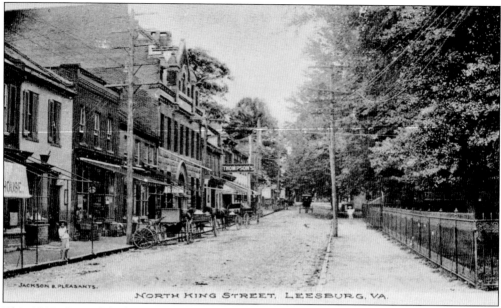

This 1907 view of the heart of Leesburg gives perspective on what it would be like to travel during the time of horses and buggies. Today's Business Route 7 (Market Street) and Route 15 (King Street) pass through this same intersection. To the right is the Loudoun County Court House Square, and behind the trees would have been the Leesburg Inn (since demolished). To the left, the tallest building was the People's National Bank, a Romanesque Revival gem. Built in 1905, it is three stories tall.

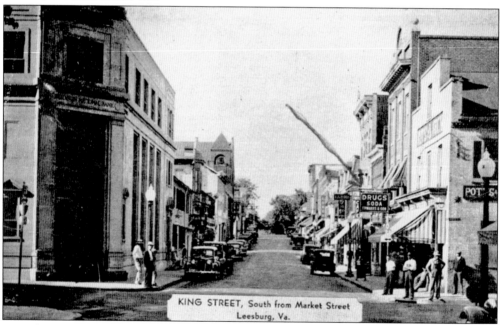

On July 3, 1938, the owner of this postcard writes, "Mr. Alexander took us to Leesburg, Va. The men went fishing. We (Frances, Betty & I) walked into the town drug store and bought something." She has drawn an arrow to point to the drugstore sign for Edwards and Son, which was located near the corner of King and Market Streets.

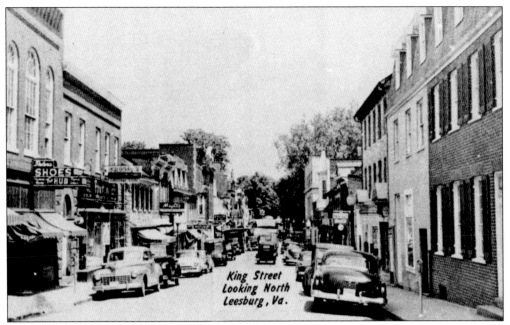

Going north on Leesburg's King Street (Business Route 15), just after it crosses Loudoun Street, one enters the heart of the historic commercial district. Some of the retail establishments that catered to the Leesburg shopper were the Hub shoe store, the Firestone tire store, the Maytag dealer, and several eateries.

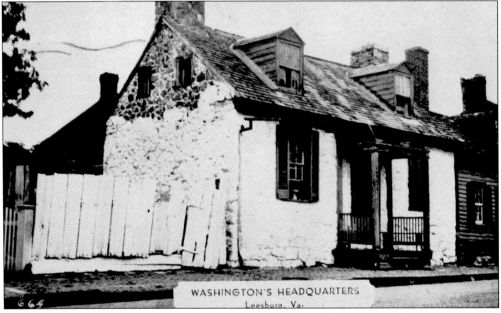

Set in historic downtown Leesburg, this postcard identifies this small stone house as "Washington's Headquarters." At one time, local lore suggested that George Washington might have had a headquarters here briefly in the 1760s during the French and Indian War. However, this structure probably is not that old. It sits next door to a 19th-century Queen Anne–style inn known as Norris House on Loudoun Street SW.

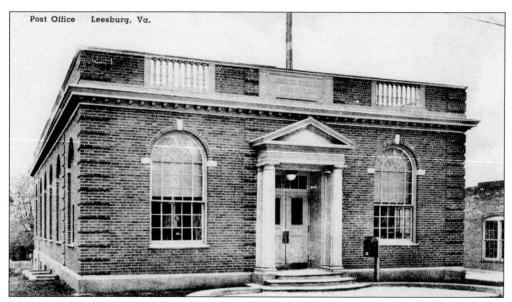

Post Office Leesburg, Va.

Like most American towns, the U.S. Post Office for Leesburg was centrally located to serve the community. Post office buildings are sources of civic pride and ways to project the community's character, so many 20th-century towns built their main post office of brick and mortar whenever possible.

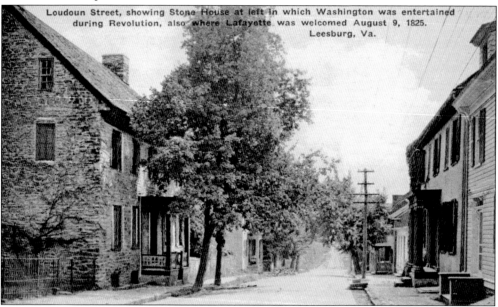

Loudoun Street, showing Stone House at left in which Washington was entertained during Revolution, also where Lafayette was welcomed August 9, 1825.
Leesburg, Va.

Downtown Leesburg contains many stone structures, including this one on East Loudoun Street. The building to the left of the street is the Patterson-McCabe House, built around the 1780s. Across the street, the building with the small porch at 7 East Loudoun Street is Osburn's Tavern, and it was built sometime in the 1790s during George Washington's presidency. In this region of the country, many old homes are often labeled as a place where Washington once slept, but almost as prevalent were the spots that the Marquis de Lafayette visited upon his return to the United States in 1825. Lafayette, a French hero who helped secure the Colonies' independence from Great Britain, was honored in every town through which he traveled.

26

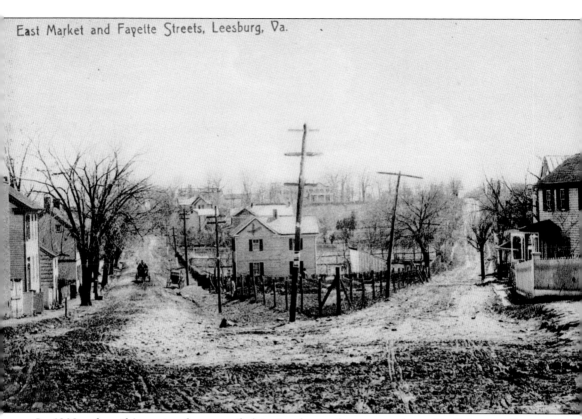

East Market and Fayette Streets, Leesburg, Va.

In 1909, when this postcard was mailed in Leesburg, the two roads at this fork were East Market and Fayette Streets. Today, to find the buildings in this view, one would have to go one block east of the courthouse to Market Street and Edwards Ferry Road. The sender of the card placed an *X* on the house on the right side of Fayette to indicate that this is where she was living in May 1909.

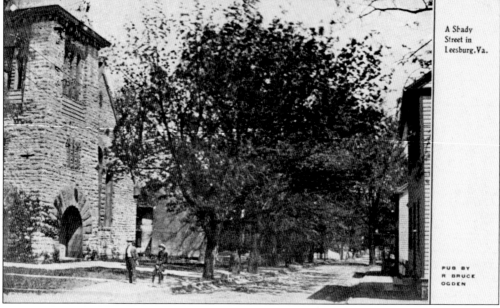

A Shady
Street in
Leesburg, Va.

PUB BY
R BRUCE
OGDEN

Leesburg was justifiably proud of its tree-lined streets in the early 20th century. This postcard, which was postmarked in 1908, highlights the shady nature of the town. Trees were important in small Southern towns before the advent of air-conditioning. This view is of Cornwall Street with St. James Episcopal Church to the left.

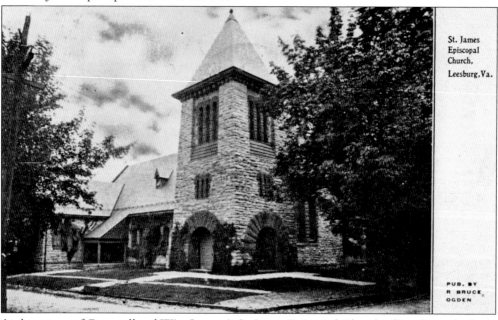

St. James
Episcopal
Church,
Leesburg, Va.

PUB. BY
R BRUCE
OGDEN

At the corner of Cornwall and Wirt Streets is St. James Episcopal Church of Leesburg. A classic example of the Romanesque Revival style, the church was built in 1895. This postcard was postmarked in October 1907, and the sender tells her sister in Paeonian Springs that she "enjoyed the train ride very much," but that she was tired upon her arrival at her home in Leesburg. Since Paeonian Springs is just to the west of Leesburg, the correspondent had probably visited some distant place and was updating her sister on her arrival home.

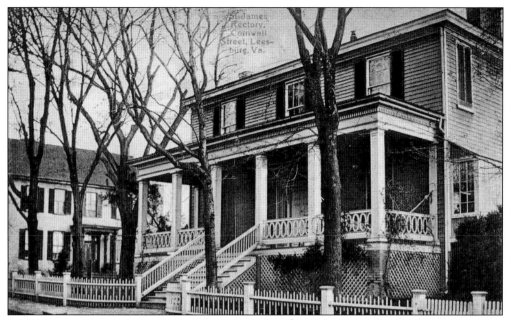

This lovely home is just down the street from St. James Episcopal Church on Cornwall Street in downtown Leesburg. The church was built in 1895, but the rectory (shown here) is estimated to have been built in the late 1850s and is in the Greek Revival style. Despite modifications to the home's exterior, the oval-shaped balusters on the porch railing are one of the features from this image that helps identify the present-day house.

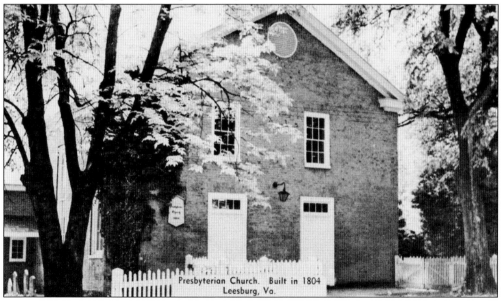

In the 200 block of West Market Street, in Leesburg's historic district, is the Leesburg Presbyterian Church, which was constructed in 1804. Two doorways front the street, and what makes this unusual is that these would not normally be considered the main entrance. The main entrance originally would have been planned facing eastward on this church. Some changes were made in the 1820s to the entries. Records suggest this may be Loudoun County's oldest church in continuous use.

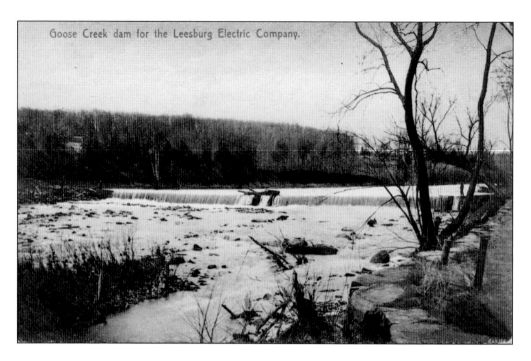

Goose Creek dam for the Leesburg Electric Company.

Before the establishment of rural electric cooperatives in the 1930s, many communities created electric companies to serve their residents. The Leesburg Electric Company used hydroelectric power from its dam, constructed on nearby Goose Creek, to electrify Leesburg. These two postcards, dated around 1914, provide views from opposite sides of the creek, showing the width of the creek and a perspective on the relatively small dam height. They would have been printed to promote the community's modern conveniences.

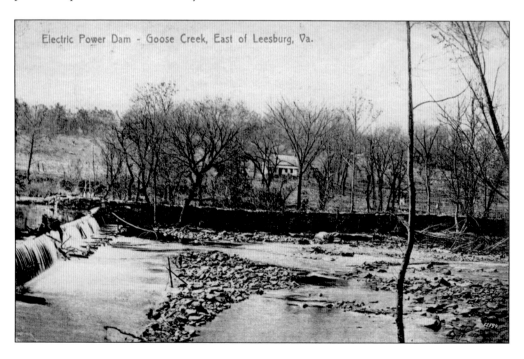

Electric Power Dam - Goose Creek, East of Leesburg, Va.

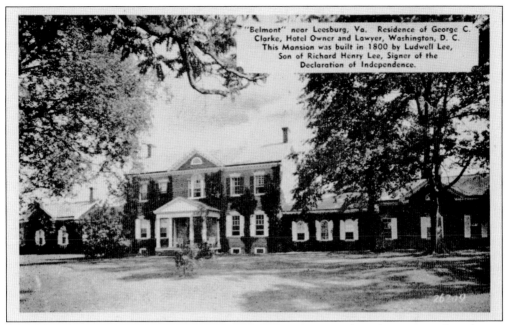

"Belmont" near Leesburg, Va. Residence of George C. Clarke, Hotel Owner and Lawyer, Washington, D. C. This Mansion was built in 1800 by Ludwell Lee, Son of Richard Henry Lee, Signer of the Declaration of Independence.

Ludwell Lee, the first owner of this home near Leesburg, was an aide to the Marquis de Lafayette during the Revolutionary War. When Lafayette made his famous return to the United States in 1825, he visited the Lees at Belmont. Other owners of the home have included a former owner of the Smithsonian's Hope Diamond and Herbert Hoover's secretary of war. Belmont remains a beautiful example of early-19th-century architecture. It is located off Route 7 near Ashburn in Loudoun County.

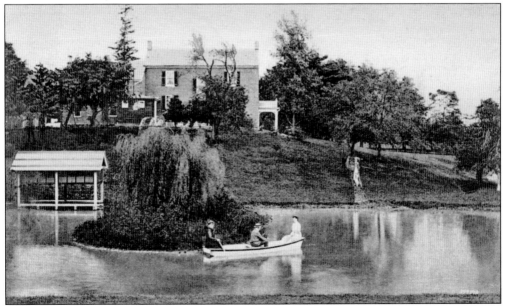

An idyllic image of life at the advent of the 20th century shows Evergreen Lodge (also known as Greenway Farm), located just south of Leesburg on U.S. Route 15. This view actually shows the rear of the house, and the pond still remains. Housing developments now close in on the home on three sides. This might be a picture of a Sunday afternoon outing among friends.

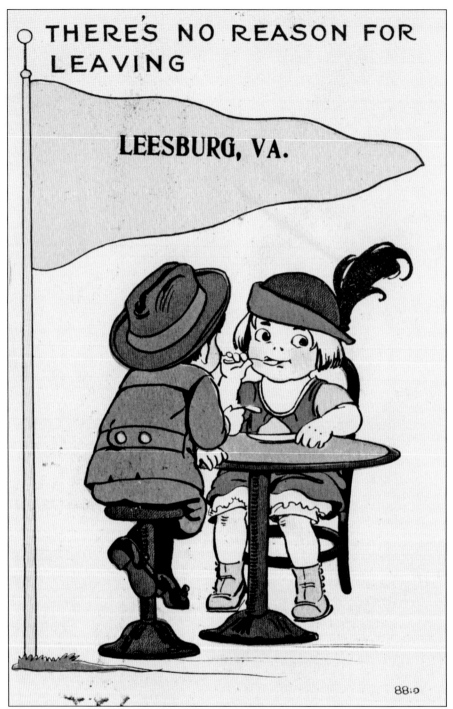

There might not have been a good reason for a person to leave Leesburg, as this 1915 postcard states, but travelers who take the roads out of Leesburg will experience even more history and beauty in Virginia's Piedmont. This is a nice example of a generic-style postcard that could be sold to retail stores in small towns across the United States. All that had to be changed during production was the name written on the pennant flag.

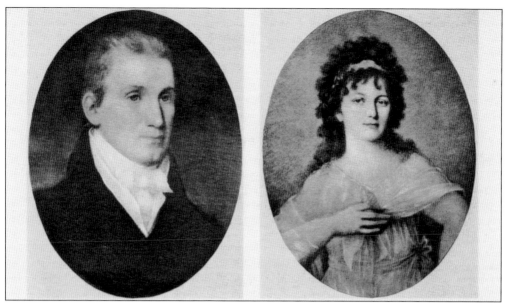

Former U.S. president James Monroe and his wife, Eliza Kortright, established ties to Loudoun County in the late 1790s, so it seems fitting to include a postcard commemorating them. This postcard dates from the 1930s. Monroe is often overshadowed today by other Virginian presidents, including George Washington, Thomas Jefferson, and James Madison, but he was a major political figure in the country's early history. Monroe and his wife are buried in a beautiful wrought-iron memorial in Richmond's Hollywood Cemetery.

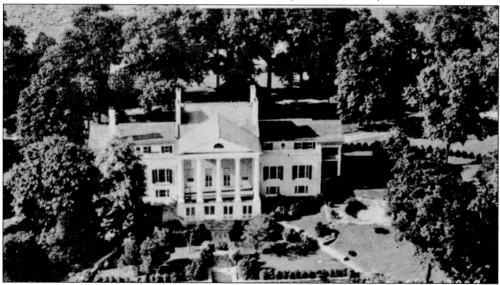

Oak Hill, near Aldie, was the home of James Monroe, fifth president of the United States, from his retirement from public service in 1825 until his wife's death in 1830. Because Loudoun County was closer to Washington, D.C., than their original home at Ash Lawn near Charlottesville, the Monroes started to spend more time at the farm near Aldie during his years of service in James Madison's cabinet from 1811 to 1816. Around 1820, during Monroe's first term as president, he and his wife sold Ash Lawn so that they could eventually retire to this farm in Loudoun County.

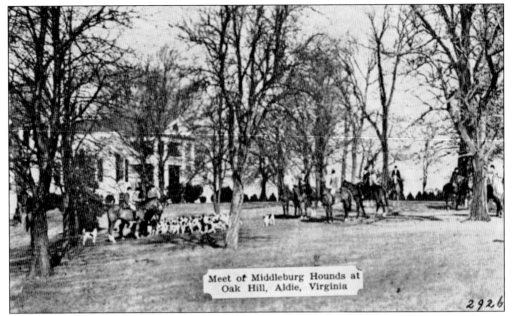

Meet of Middleburg Hounds at
Oak Hill, Aldie, Virginia

2926

Despite it being a president's home, Oak Hill has remained a private residence. James Monroe's home is located a few miles north of the intersection of U.S. Routes 15 and 50 at Gilberts Corner. As seen in this view, it has been the site of fox hunts, an ever popular pastime among the equestrian community of this Piedmont region.

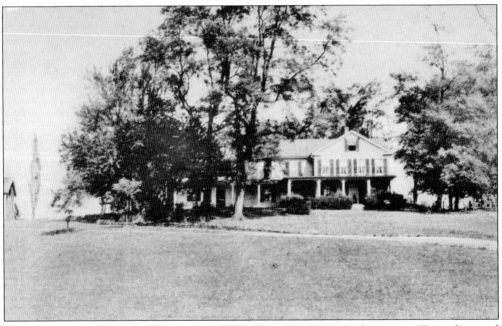

This house is identified on the reverse as Hill Crest of Aldie. The home is still standing and looks remarkably the same. It is located west of Aldie and east of Middleburg on the north side of U.S. Route 50.

SCENIC BEAUTY
Near Middleburg, Virginia

This type of scenery is why so many people visited the rolling hills of the Piedmont during the summer. Staying in the countryside was a popular event for many in Washington, D.C., during the summers before air-conditioning was developed. The hills and trees would have made the hot and humid summers more tolerable, or at least the change of scenery would have been welcomed, even if it was just as hot.

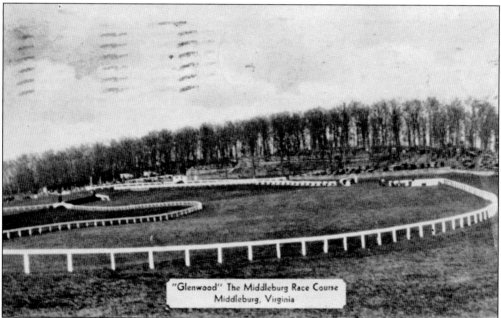

"Glenwood" The Middleburg Race Course
Middleburg, Virginia

Before 1932, the Glenwood Park Course was known as the Middleburg Hunt Course, and over the years, this course has drawn some of the best hurdle horses in the country to the hurdle contest and stakes races held here each year. The park is located north of Middleburg off Foxcroft Road.

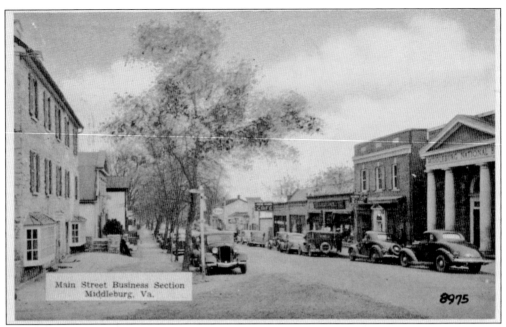

Main Street Business Section
Middleburg, Va.

8975

This is Middleburg as it probably looked in the late 1930s. While labeled "Main Street," it is actually Washington Street (U.S. Route 50). As was true everywhere, Middleburg felt the economic impact of the Great Depression, but the business district still supported an Esso station, a café, and the Middleburg National Bank. To the left side of this view is the historic Red Fox Tavern, which has stood on this corner since at least the 1830s.

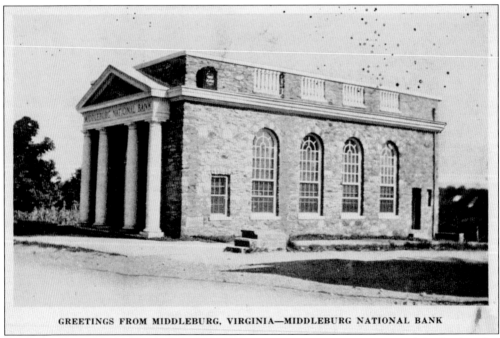

GREETINGS FROM MIDDLEBURG, VIRGINIA—MIDDLEBURG NATIONAL BANK

A postcard like this was probably made to commemorate the construction of the bank. This appears to be the bank located in the heart of Middleburg on Washington Street, but what is confusing about this image is that no buildings appear to be around the bank.

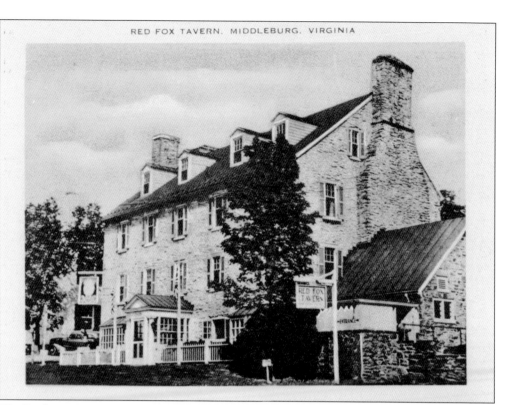

The Red Fox Tavern or Inn is a significant fieldstone structure in Middleburg's historic district. Located at 2 East Washington Street, some parts of the building are believed to date to the early to mid-1700s. It has been expanded periodically from the 1830s into the 20th century, and it may be one of the oldest continually operating inns in the United States.

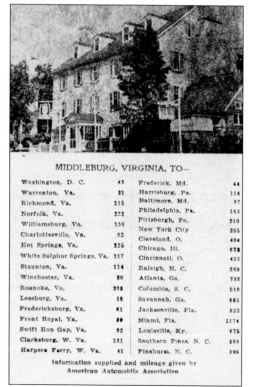

An advertisement for the Red Fox Tavern in Middleburg, this postcard states on its reverse that the tavern was established in 1728. Most likely a pre-1940s postcard, it serves the purpose of telling travelers that Middleburg is "not too far no matter where you are" in the eastern part of the United States by giving travel distances provided by the American Automobile Association (AAA).

MIDDLEBURG, VIRGINIA, TO—

Location	Miles	Location	Miles
Washington, D. C.	43	Frederick, Md.	44
Warrenton, Va.	11	Harrisburg, Pa.	114
Richmond, Va.	115	Baltimore, Md.	87
Norfolk, Va.	222	Philadelphia, Pa.	163
Williamsburg, Va.	138	Pittsburgh, Pa.	210
Charlottesville, Va.	92	New York City	255
Hot Springs, Va.	225	Cleveland, O.	404
White Sulphur Springs, Va.	217	Chicago, Ill.	673
Staunton, Va.	114	Cincinnati, O.	457
Winchester, Va.	30	Raleigh, N. C.	389
Roanoke, Va.	202	Atlanta, Ga.	733
Leesburg, Va.	15	Columbia, S. C.	510
Fredericksburg, Va.	81	Savannah, Ga.	665
Front Royal, Va.	39	Jacksonville, Fla.	823
Swift Run Gap, Va.	92	Miami, Fla.	1174
Clarksburg, W. Va.	181	Louisville, Ky.	675
Harpers Ferry, W. Va.	41	Southern Pines, N. C.	389
		Pinehurst, N. C.	396

Information supplied and mileage given by American Automobile Association

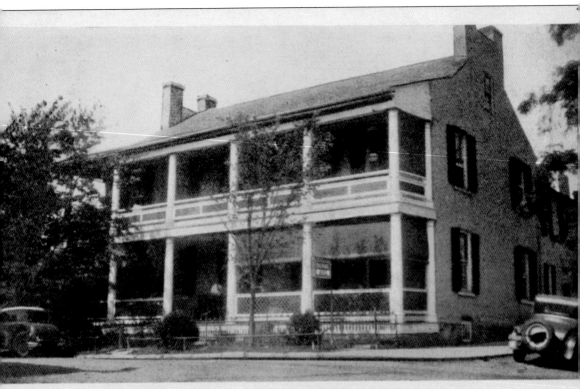

GREETING FROM MIDDLEBURG, VIRGINIA—COLONIAL INN

Visitors today would have a tough time identifying the building from this postcard. The porches were removed in 1980, and it has had several aliases over its history besides the Colonial Inn. Built around 1830 by Noble Beveridge, it is sometimes called the Noble Beveridge House. In more recent years, the Colonial Inn has also been called the Windsor House Inn. It is located near the Red Fox Tavern on Washington Street and can be identified by its distinctive end chimneys atop the two-story structure with five window bays.

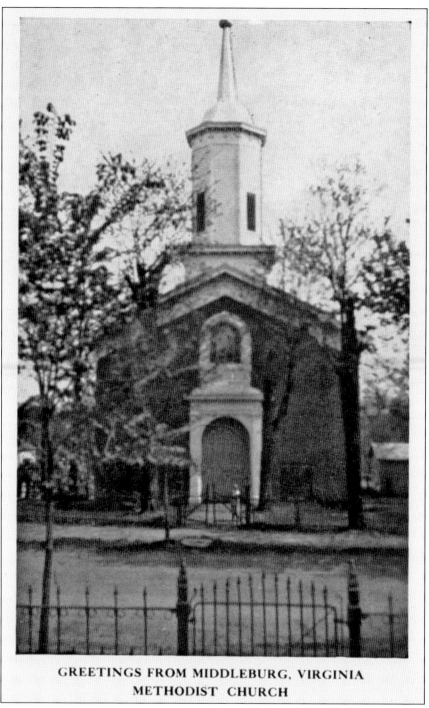

GREETINGS FROM MIDDLEBURG, VIRGINIA
METHODIST CHURCH

Middleburg Methodist Church sits on Washington Street (U.S. Route 50) in the town's historic district. Construction started on this church prior to the Civil War in 1858, but it was not completed until hostilities had ceased. It is a beautifully proportioned structure with an octagonal belfry tower. This image dates to a time when Washington Street was still a dirt road.

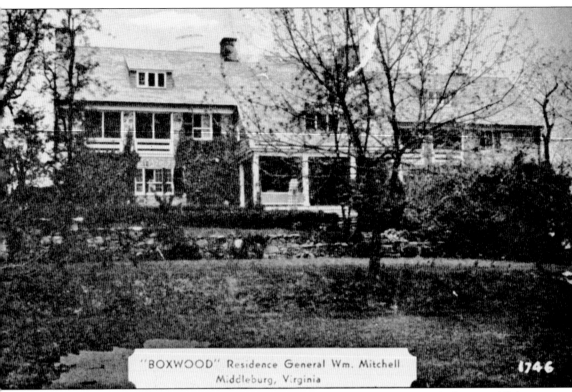

"BOXWOOD" Residence General Wm. Mitchell
Middleburg, Virginia

1746

Boxwood, a private residence in Fauquier County, is located less than one mile from Middleburg off U.S. Route 50 on County Road 626. It is best known as the home of Gen. William "Billy" Mitchell from 1925 until his death in 1936. During the 1920s, Billy Mitchell's advocacy for military aviation cost him his military career. He resigned from the army after being court-martialed for insubordination, but he continued writing and speaking about the importance of military aviation and the need for an independent air force until the time of his death. Mitchell's predictions about how aviation would be used in future wars, and particularly, his view on the threat of the Japanese in the Pacific, turned out to be remarkably accurate. He was honored posthumously with promotion to the rank of major general and with the naming of one of the main buildings at the U.S. Air Force Academy in his honor.

Two

WARRENTON (FAUQUIER COUNTY) AND VICINITY

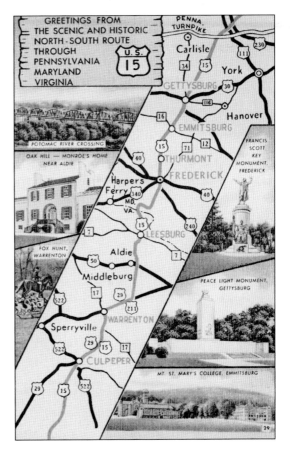

On this section of the journey along Route 15 traveling southward, one will see the rolling hills and horse country of Fauquier County while heading toward Warrenton. Traversing the county of John Marshall and Virginia's Gold Cup Races, fellow travelers from bygone days used this opportunity to send these postcards from the towns and villages of Upperville, Paris, Delaplane, Marshall, The Plains, and Warrenton.

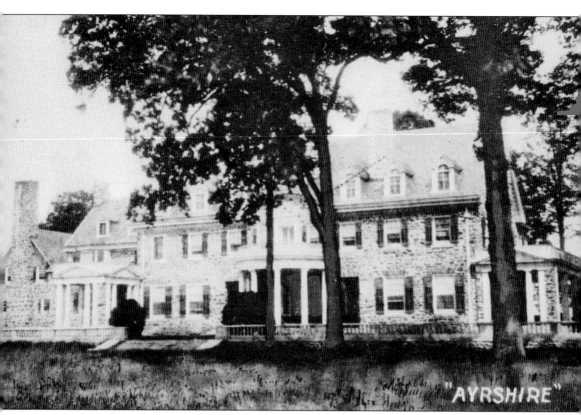

"AYRSHIRE"

This house is located near Upperville, on U.S. Route 50 on the Loudoun–Fauquier County border west of Middleburg. Ayrshire existed in some form prior to the Civil War and was used as a headquarters by one of Confederate colonel John Mosby's men. Brig. Gen. James A. Buchanan occupied the home soon after his retirement from the U.S. Army and probably was the owner of the house at the time this postcard was published. General Buchanan served in the U.S. Army from 1867 to 1906 at army posts during the Indian Wars, in Puerto Rico, and in the Philippines. Before his death in 1926, the stables at Ayrshire were known as one of the finest in the state for breeding Thoroughbred horses.

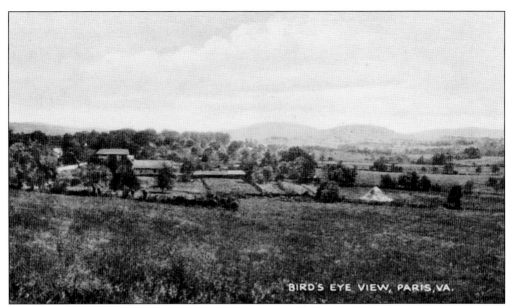

To identify this as a "Bird's Eye View" seems to be an exaggeration since the photographer appears to be standing on a low hill just outside the hamlet. Paris is located at the junction of U.S. Route 17 and U.S. Route 50, has a designated historic district listed on the National Register of Historic Places, and is set in a valley with the Blue Ridge Mountains and Ashby Gap nearby.

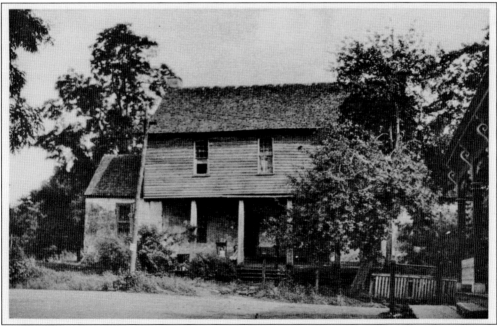

This picture postcard is identified as being Ashby's Tavern in Paris. A tavern operated at this location from the early 1800s until 1869. After that time, until the late 1930s, it was only used as a residence. Located at the intersection of Federal Street and Gap Run Road, the building was significantly damaged when a truck crashed into it in 1937 or 1939, and it was torn down. A service station replaced the old tavern.

SHACKLETT STORE AND STATION, DELAPLANE, VA.

When the Manassas Gap Railroad first arrived in this part of northern Fauquier County, this stop was known as Piedmont Station. In 1874, the named was changed to Delaplane, which was the name of the family that ran the post office and country store at that time. As owners changed, the store was later known as Turner Seaton's and then Shacklett's. The latter name was in use when this postcard was sent in 1909. The Delaplane train station is visible across the railroad tracks to the right side of the view. Delaplane is of historical significance because it was here that the Confederate army became the first army to use trains to rapidly move troops into combat for the 1861 Battle at Manassas.

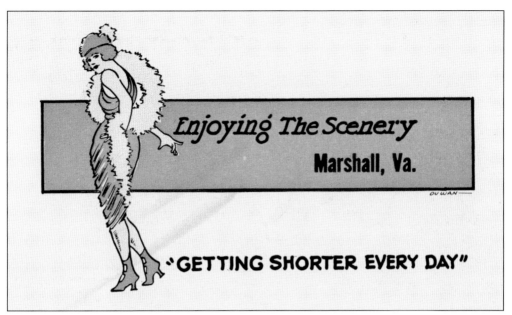

These two cards are for the small town of Marshall. Rather than paying for an image of the area, a local merchant contracted for a series of humorous cards that were imprinted with this Fauquier County town's name. Before the 1880s, the community was known as Salem, but the name was changed to recognize the fact that Supreme Court chief justice John Marshall's father once owned land in the vicinity.

These cards appear to date to the 1910s–1920s era. Society was trying to get accustomed to changes in women's fashions, with hemlines rising and more women showing their legs. "Getting shorter every day" is a mock response to fashion and perhaps to vacations getting shorter as well. The other issue about which men were clucking was whether it was proper for women to work outside the home. So this image of a woman telegram messenger also spoofs the notion that women wanted to work.

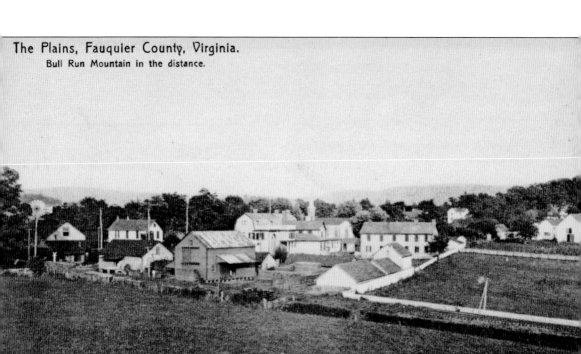

This postcard gives a perspective on the size of the community known as The Plains prior to 1918. In earlier times, the community was once called The White Plains, but confusion with White Plains, New York, led to the name change. Looking eastward toward the Bull Run Mountain are the tops of the Masonic Lodge and the Orange County Hunt (O.C.H.) building (the gambrel-roof structure). The steeple, just beyond the O.C.H building, is the 1855 version of Grace Episcopal Church. These buildings are all along the John Marshall Highway or Route 55. Because the new church was not built until 1918, this photograph must have been taken before that date.

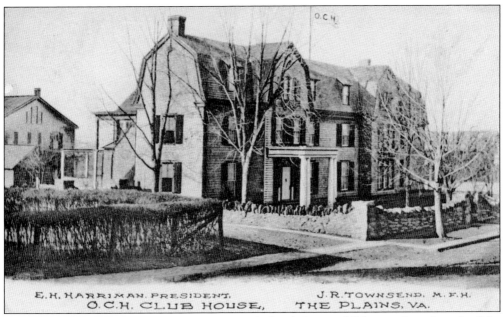

A group of dedicated foxhunters from New York decided to establish a southern branch of the Orange County Hunt club in Fauquier County near The Plains so as to have a longer hunting season. The club's president listed on this postcard was Edward H. Harriman, the Union Pacific Railroad's director. "J. R. Townsend, M.F.H." was John R. Townsend, master of foxhounds. The building, located along Route 55, was destroyed by fire on February 21, 1967, after a fuel oil tank truck hit a freight train on the nearby railroad tracks.

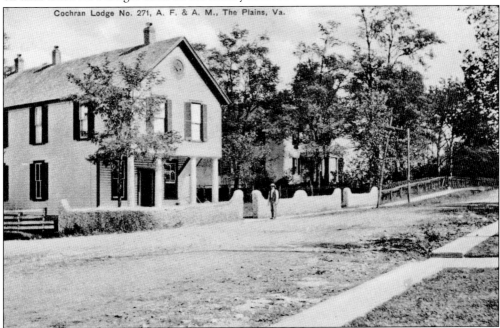

As the John Marshall Highway (Route 55) passes through The Plains, it passes the Cochran Masonic Lodge No. 271 at 6514 Main Street. The front of the building has significantly changed since this postcard was first published in 1909, but it remains a Masonic Lodge.

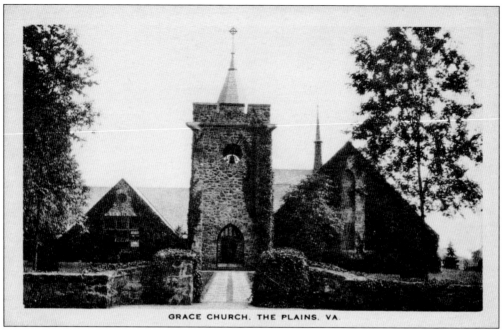

GRACE CHURCH. THE PLAINS. VA.

Located at 6507 Main Street (or Route 55 West) in the little burg of The Plains is Grace Episcopal Church of the Whittle Parish. The church was built in 1918 of nearby fieldstones and was located on the site of the earlier church, which had been built in 1855. The bell in this church's tower was taken from the old Grace church's belfry.

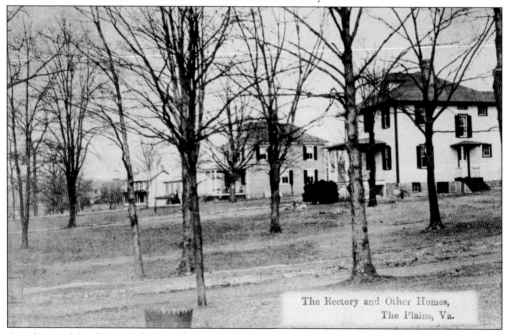

The Rectory and Other Homes, The Plains, Va.

On the road leading south out of The Plains in Fauquier County, these homes line the Old Tavern Road/Fauquier Street. Because the photographer captured several homes in this photograph, it is not clear which one is the rectory, but the minister would have had a short stroll across the road to reach Grace Episcopal Church.

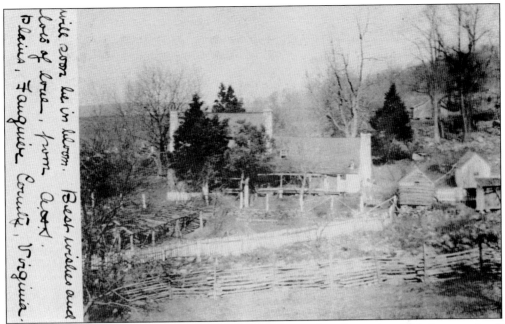

The author of this postcard identifies this as "an old time farm house in which I am staying." As the postcard is postmarked March 1909, it is indeed "an old time farm house." In the foreground is a split-rail fence, and the land appears to be strewn with rocks, which would make for tough farming.

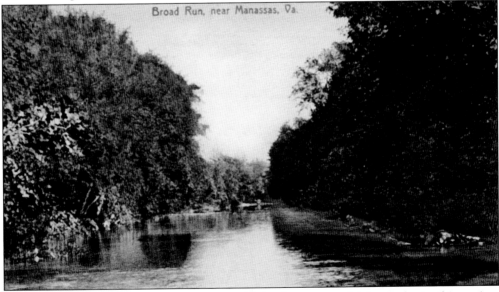

Broad Run, as a stream name, appears multiple times on multiple creeks in this region. Fortunately, this postcard publisher aided the scene's identification somewhat by noting that this stream was "near Manassas." In the vicinity of Chapman's Mill between Fauquier and Prince William Counties, this version of Broad Run meanders its way to eventually join the Occoquan River. It was probably selected for a postcard subject because the stream passes near the Manassas Gap railroad line. Passengers could then purchase a local view at the train stop. This particular postcard was postmarked "Nokesville, VA, 1910."

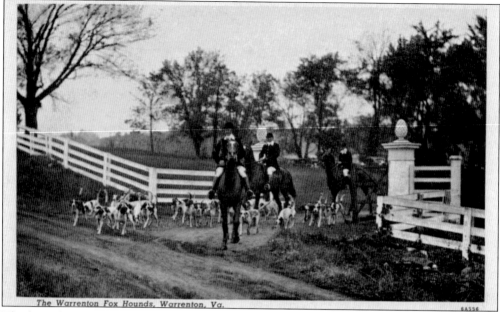

The Warrenton Fox Hounds, Warrenton, Va.

The hounds and riders set out for the foxhunt somewhere near Warrenton, probably in the 1940s. Virginia, and particularly the upper Piedmont region, has had many active foxhunt clubs since the early 1900s.

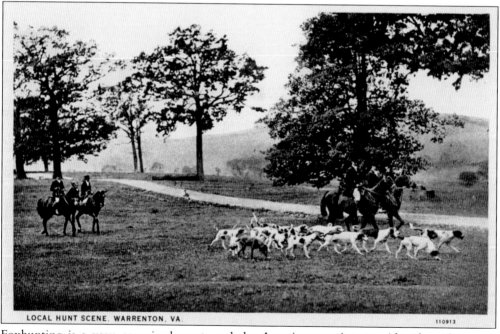

LOCAL HUNT SCENE, WARRENTON, VA.

Foxhunting is a very organized sport, and the American version provides the riders with the special experience of enjoying the thrill of the horse ride along with the beauty of the scenery. Because of the rolling hills of the Piedmont region, foxhunting remains a popular sport among horse riders.

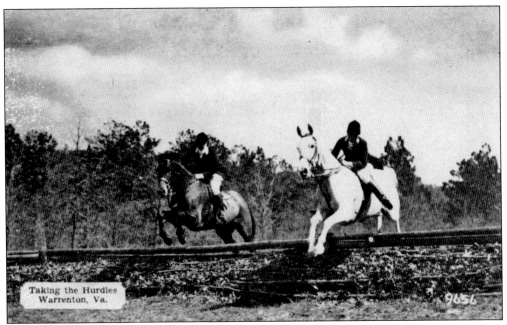

Taking the Hurdles
Warrenton, Va.

9656

This is probably a photograph of the Gold Cup Races sometime during the 1940s. Held since the 1920s, these steeplechase races draw thousands of spectators every year. While the course location has changed over the decades, it has always been held in Fauquier County.

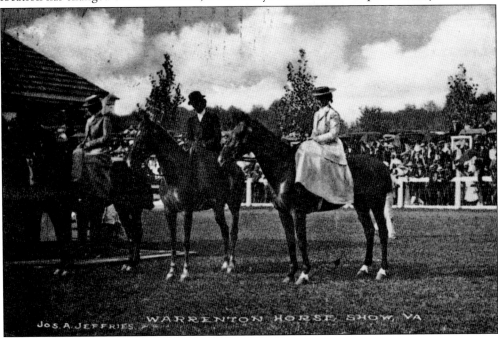

JOS. A. JEFFRIES WARRENTON HORSE SHOW, VA

Few commercially made postcards from the early 1900s show women, and fewer still show women doing any type of sporting activity, so this image of women at a horse show in Warrenton sitting sidesaddle is unusual. The postmark is from Warrenton and appears to be dated 1910. It reports that there was hot weather in America, and the card was mailed to a young man in Switzerland.

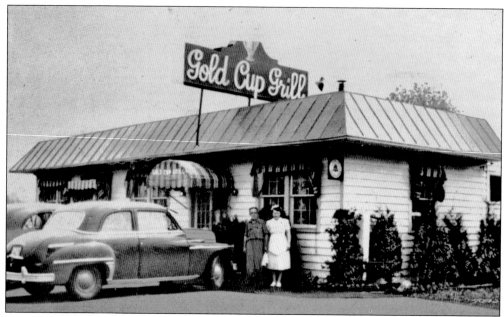

The Gold Cup Grill owed its name to the nearby horse races of the same name. The restaurant once served travelers on the Warrenton Bypass. It has since been replaced by other commercial ventures, but according to this card, it was known for "good food-cleanliness-prompt service and popular prices." As another service to its patrons, there was a pay phone inside, as indicated by the Bell Telephone sign on the corner of the building.

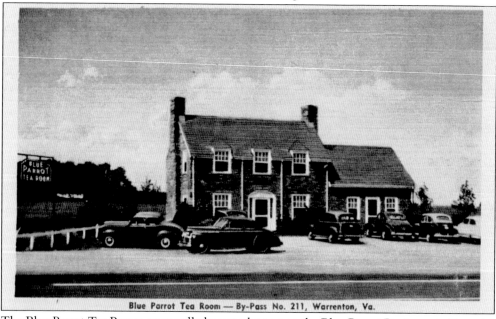

Blue Parrot Tea Room — By-Pass No. 211, Warrenton, Va.

The Blue Parrot Tea Room eventually became known as the Blue Parrot Restaurant. To make way for highway improvements around Warrenton, the building has been torn down. This 1940s-era postcard advertises the Blue Parrot as "[f]amous for southern food and hospitality. Serving breakfast, lunch and dinners. Featuring chicken, steak and Va. ham. Plenty of parking space [sic]."

The town of Warrenton was laid out in 1790 and was incorporated in 1810. Its earliest name was Fauquier Court House, and it is believed the town was renamed to honor Dr. Joseph Warren, who was associated with Revolutionary hero Paul Revere and who was later killed at the Battle of Bunker Hill. Another variation on the naming of Warrenton is that the town derived it name from a local school, the Warren Academy. This generic postcard would have been imprinted by a print shop with a community's name based upon orders received from local drugstores or country stores.

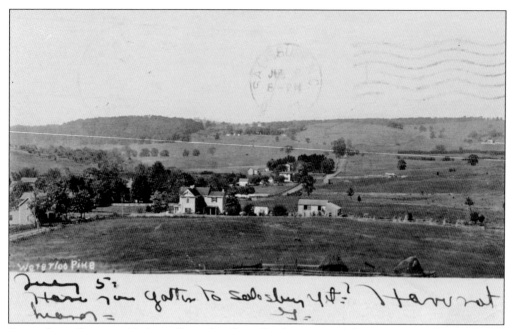

Long after tolls stopped being collected, toll roads often retained their turnpike or pike names. This cross-county turnpike took travelers from Warrenton in Fauquier County toward the Blue Ridge Mountains. Waterloo was once a prime crossing point over the Rappahannock River to points west or southwest. Today's U.S. Routes 15, 29, and 211 bypass the little village of Waterloo and the pike.

Without any definitive landmarks in this view, it is not possible to identify this location other than being "northwest from Warrenton." Fields like these have been replaced by subdivisions, but the rolling hills still remain.

A landscape of hills and fields surrounded the town of Warrenton for many years. Now subdivisions cover most of this land. Why this scene was made the subject of a postcard is unknown, but the expanse of what once was is now mostly only a memory.

The natural beauty of Virginia's Piedmont region provides a photographer with an endless opportunity to make great images. With not a house in sight and the hay having been harvested, it is easy to see why someone stopped to snap this picture for a postcard. A traveler might have written something like this on it for the folks back home, "Traveled through this beautiful countryside today. The weather was a bit warm, but we had a nice breeze. Wish you were with us!"

SCENE NEAR WARRENTON, VA.

Upon entering Warrenton from the east, this view toward Fauquier County's courthouse would once have been possible. This section of street is still known as the Alexandria Pike, and the pike was the main road between Warrenton and Alexandria. To get this view today, one would have to travel to a dead end down the hill from the courthouse in downtown Warrenton. The Alexandria Pike has been severed by a bypass around the town that prevents present-day travelers from seeing more of the original road.

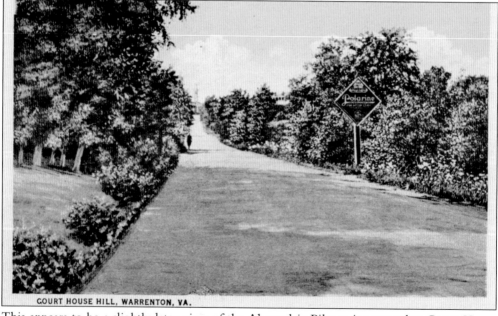

COURT HOUSE HILL, WARRENTON, VA.

This appears to be a slightly later view of the Alexandria Pike as it approaches Court House Hill. To the right of the road is a Polarine advertisement. Polarine was a Standard Oil brand of gas and oil, which makes the location of this sign ideal. In the early days of automobile travel, this would have been a welcome sign for the Model T chugging into town needing to refuel.

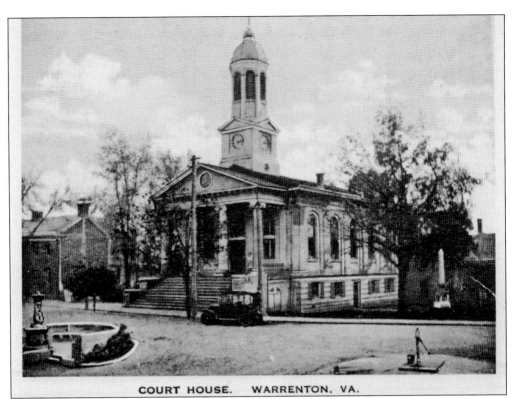

COURT HOUSE. WARRENTON, VA.

This is estimated to be a postcard from the second decade of the 20th century showing the intersection in front of the Fauquier County Court House. Visible to the right foreground is a water well for use by the town's residents. In the left foreground is a semicircular park bench directly in the intersection. Today it is hard to conceive that such a location would be a desirable place to sit, which speaks to how much times have truly changed.

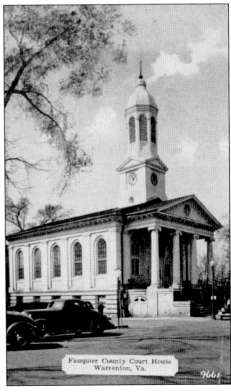

Fauquier County Court House
Warrenton, Va.

Warrenton is the county seat for Fauquier. On the town's central hill sits the courthouse, which was originally constructed in 1853–1854 and which appears in various Civil War–era photographs taken during the Union army's occupation of the town. In 1889, as citizens celebrated election results, they sparked a fire that destroyed the entire courthouse except for its exterior walls. Some of the structure was salvaged, and the same basic floor plan was used to rebuild the courthouse. That building is what a visitor sees today.

57

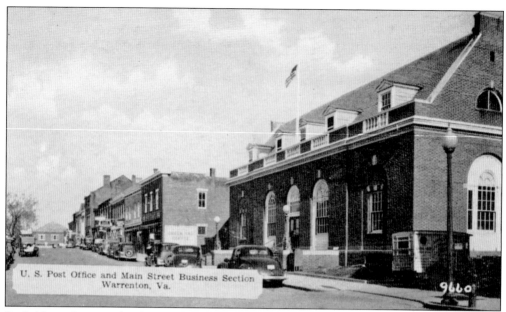

U. S. Post Office and Main Street Business Section
Warrenton, Va.

Probably a photograph of Warrenton's Main Street in the 1930s, this is a typical scene for a town of the era. The 1916 post office is located on the right (the building with the flag) at 53 Main Street. An advertisement for Green Bag Coffee is painted on the side of the building next to the post office. What appears to be an early postal delivery truck sits in the shadows next to the post office.

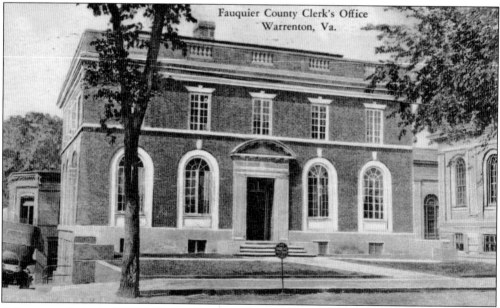

Fauquier County Clerk's Office
Warrenton, Va.

Adjacent to the courthouse, the county clerk's office sits at the corner of Culpeper and Main Streets. Many towns had postcards like this one to promote civic pride and to encourage businesses' confidence. It showed that a town like Warrenton was progressive enough to build a solid building like this for its records office. Notice the open window, which along with the car's vintage, suggests that this picture was taken well before air-conditioning. However, one thing never seems to change—there is a "No parking" sign located directly in front.

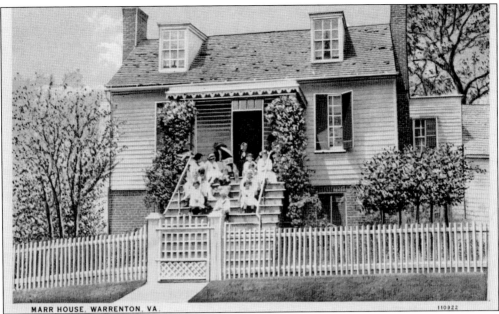

MARR HOUSE, WARRENTON, VA. 110922

Capt. John Quincy Marr lived in this home on Culpeper Street in Warrenton before the start of the Civil War. He was the first Confederate officer killed in the long and bloody war, which later led to at least one street being named in his honor (in Annandale, Virginia) and postcards of his home being published around the time of the Civil War's 50th anniversary.

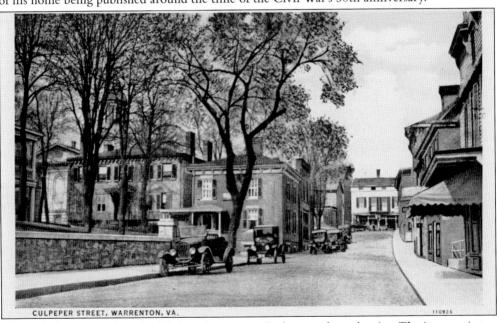

CULPEPER STREET, WARRENTON, VA. 110926

Through the trees and to the left in this view stands the courthouse's spire. The intersection at the end of the street is Culpeper and Main Streets in downtown Warrenton. A point of civic pride is showcased in the paved streets and pristine sidewalks along both sides of the street. Businesses and homes forever needed to be cleaned in the time of dirt streets when windows were opened for ventilation and cooling. The shift to pavement and the subsequent elimination of mud and dust were major improvements in the lives of a town's residents.

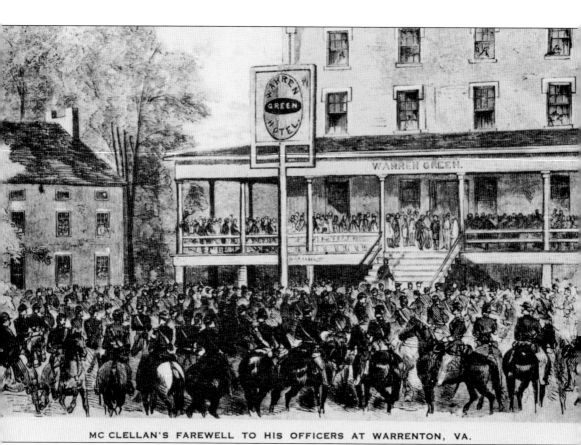

MC CLELLAN'S FAREWELL TO HIS OFFICERS AT WARRENTON, VA.

In 1862, Abraham Lincoln relieved Civil War general George McClellan of command of the Army of the Potomac. In taking the leave of his officers in Warrenton, General McClellan gave a speech from the porch of the Warren Green Hotel. *Harper's Weekly* commemorated that scene in a woodcut engraving that was published in an issue in November 1862. This postcard uses that image to commemorate a historic moment for the town of Warrenton.

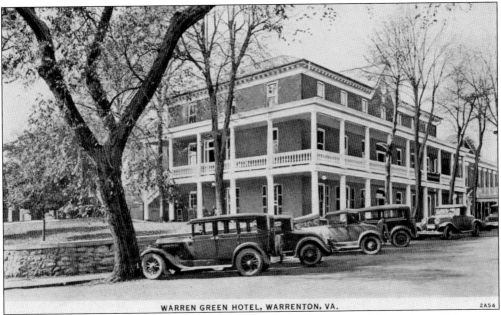

WARREN GREEN HOTEL, WARRENTON, VA.

2A54

The Warren Green Hotel sits along the aptly named Hotel Street. Using the vehicles as an aid to date this photograph, it was probably taken in the 1920s. The hotel occupies the block behind the courthouse. The porch, in the foreground, looks much like the one in a *Harper's Weekly* block engraving showing the scene of Gen. George B. McClellan's farewell to his troops in November 1862 after the Battle of Antietam. However, since the hotel was damaged by fire in the 1870s, it is likely this is a rebuilt section of the antebellum hotel.

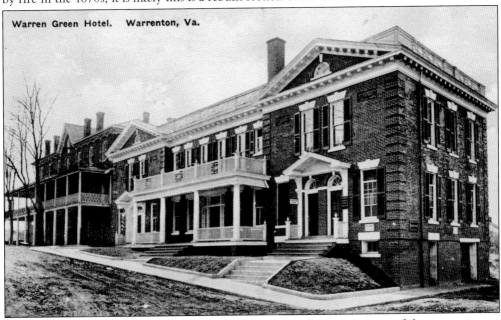

Warren Green Hotel. Warrenton, Va.

The Warren Green Hotel last served guests in the early 1960s, but some of those guests were certainly memorable, including Wallis Warfield Simpson, the future Duchess of Windsor. Many of the affluent guests were drawn to the Warren Green because of its central location between the Fauquier Springs and the site of the Gold Cup Races.

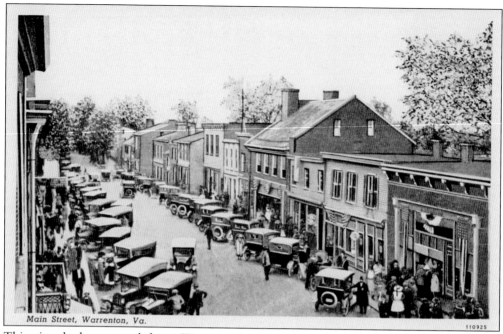

Main Street, Warrenton, Va.

This view looks eastward down Warrenton's Main Street. The number of people and cars, and the bunting on the buildings suggest a special event, perhaps a Fourth of July celebration in the 1920s.

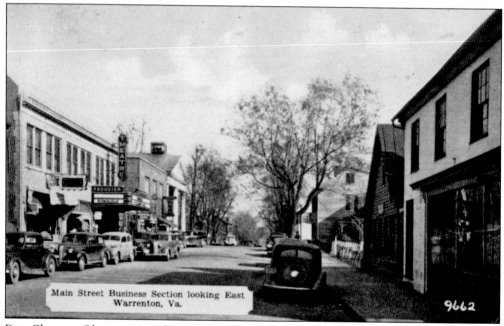

Main Street Business Section looking East
Warrenton, Va.

Pvt. Clarence Olson, stationed at nearby Vint Hill Farms, mailed this postcard 10 days after D-Day in 1944. He tells Mr. and Mrs. Olson that the fire station is the place with the columns and that the post office (from which he was mailing this card) "is just down a bit further on the left." The Fauquier Theater was showing the film *Honolulu*.

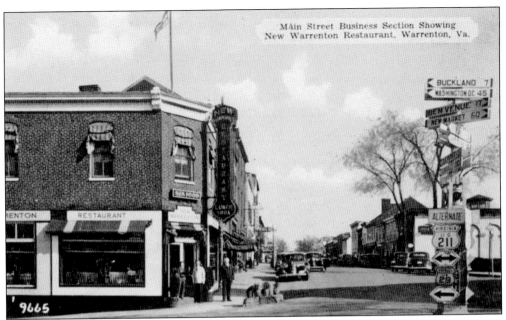

In the foreground is a street sign with directions and mileage from downtown Warrenton. Imagine being from out of town and trying to find your way by reading these signs as you pass by! This is the intersection of Alexandria Pike, Winchester Street, and Main Street adjacent to the Fauquier County Court House. Prominently placed on the corner is the New Warrenton Restaurant, which served lunch, soda, and seafood.

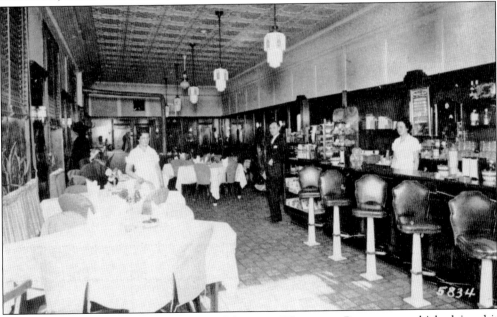

In the late 1930s, this was the interior of the New Warrenton Restaurant, which claimed it was "home of famous food" and that "Wally Simpson (now Duchess of Windsor) dined at this restaurant during her stay in Warrenton in 1927." Here the staff stands ready to serve the hungry patrons who are sure to soon arrive. In an ironic twist, at the end of the sandwich counter, there can be seen a postcard stand filled with postcards of the same vintage as this one.

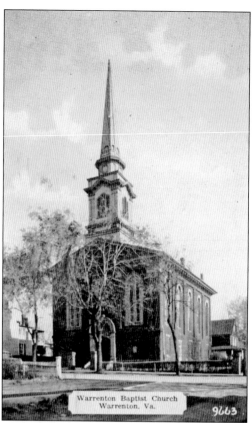

The Warrenton Baptist Church, located at 123 Main Street, has been described as a "high-style Italianate ecclesiastical architecture" in the National Register of Historic Places. It was built in 1871, so unlike some of Warrenton's other churches, it could not have been used as a hospital during the Civil War.

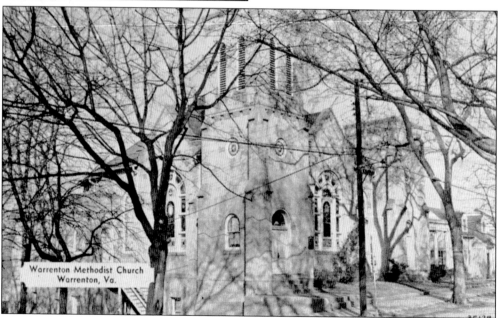

Barely visible through the trees sits what was originally the Warrenton Methodist Church, located at 46 Winchester Street. Built around 1890 in the Romanesque Revival style, the church is now the home of the Warrenton Bible Fellowship.

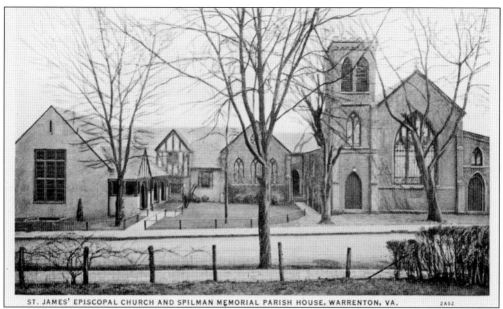

ST. JAMES' EPISCOPAL CHURCH AND SPILMAN MEMORIAL PARISH HOUSE, WARRENTON, VA. 2A52

This is a post–1912 view of St. James's Episcopal Church in downtown Warrenton. Two clues lead to that conclusion: first, the style of the postcard; and second, the church burned around 1910, leading to a rebuilt structure that lacked a steeple on the tower to the right. Located at 73 Culpeper Street, the main church is in the Gothic Revival style , while the adjacent parish hall (left) is in the Tudor Revival style. Irwin Fleming was the architect for the 1912 reconstruction of St. James's.

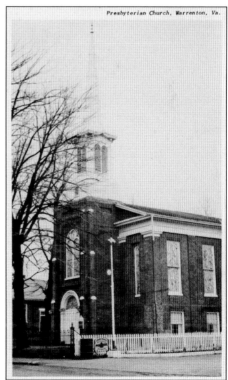

Built in the Greek Revival style of the 1850s, the Warrenton Presbyterian Church, located at 91 Main Street, was modified somewhat after the Civil War. The church was used, like so many of the community's buildings, as a hospital facility for Union soldiers who were wounded on nearby battlefields.

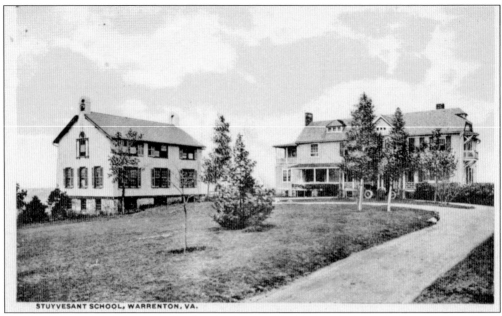

STUYVESANT SCHOOL, WARRENTON, VA.

The 1916 edition of *A Handbook of American Private Schools* states that Edwin B. King (Yale 1898) is the headmaster of the Stuyvesant School in Warrenton. The school had 100 percent enrollment with 35 students in attendance. "As the school is small much individual attention is possible." An "elastic curriculum" was advertised, and the terms cost $600 per year per student, quite expensive at that time.

"The Gardens"
Stuyvesant School
Warrenton, Va.

Young men are seen studying in the gardens at the Stuyvesant School, which was located just north of historic downtown Warrenton. The *Handbook of American Private Schools* from 1916 describes the school as "[b]eautifully located at a high altitude in an invigorating climate. One hundred acres for outdoor sports. Prepares efficiently for college." Today one probably will not find descriptions of Warrenton as being at "high altitude."

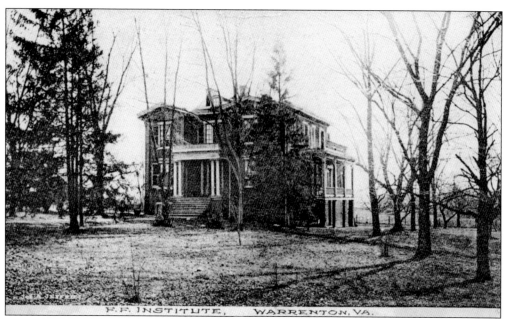

The F. F. Institute was the Fauquier Female Institute, and this 1857 Italianate-style building still stands just off Lee Street in the town of Warrenton. It continued to operate as a girls' school until the early 1920s. One story indicates that Gen. Douglas MacArthur spent some time here as a young boy while visiting an aunt who lived in Warrenton.

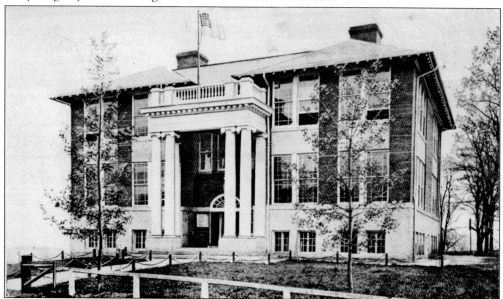

Fauquier County was the location a number of private schools for both boys and girls starting in the late 1800s. Public schools like this one became more prevalent in the early 1900s, and for a number of years, this school served as the high school for the white students around the town of Warrenton. During this era, the school system was segregated, with limited educational opportunities for the county's African American student population. That was such an assumed part of life that a postcard like this did not even bother to identify this as a whites-only school.

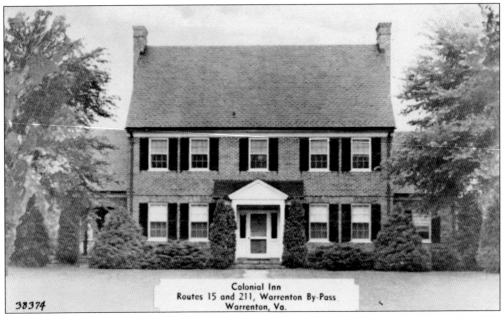

Colonial Inn
Routes 15 and 211, Warrenton By-Pass
Warrenton, Va.

38374

This postcard states that Mrs. R. L. Moser operated the Colonial Inn on the Route 15, 211, Warrenton Bypass. The inn offered "private and connecting baths, hot water heat, continuous hot water, locked garages, inner-spring mattresses." What more could a guest ask for?

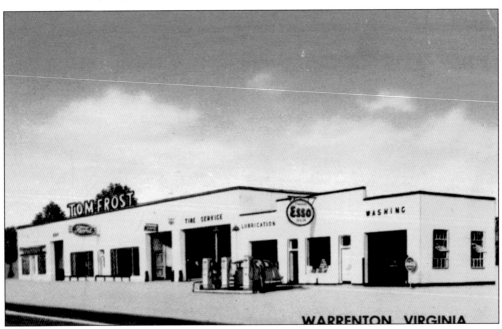

Tom Frost of Warrenton could handle all of a customer's automotive needs. Running a Ford-Mercury and Firestone dealer and Esso service station, Frost could provide "complete auto service" as one traveled through Warrenton. A business like this one brings to mind the differences between a service station of yesterday and a gas station of today. At a place like this, an attendant would have come out to fill up the tank, clean the windows, and check under the hood—that is what sets a service station apart from a gas station!

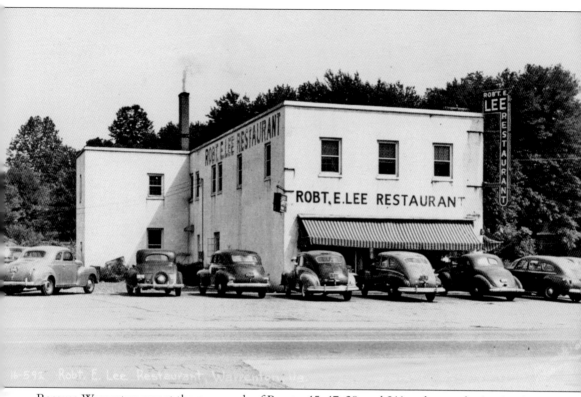

Because Warrenton was at the crossroads of Routes 15, 17, 29, and 211 and was a destination in itself, many restaurants lined the major thoroughfares. This building housed the Robert E. Lee Restaurant in the 1940s and actually has been occupied by several eateries and other businesses over the years. Located at the intersection where travelers to and from the new Shenandoah National Park would pass by, it catered to the flocks of sightseers out for a day trip from the Washington, D.C., area.

Culpeper Stree

Leaving Warrenton to head south to Culpeper in 1913, when this postcard was mailed, one would have traveled on Culpeper Street. Culpeper Street then became the Culpeper Turnpike. Five miles farther, one would reach Fauquier Springs. The writer states he "forded [a] stream

arrenton, Va.

and had all kinds of rough roads" and was making 75 miles in a day. Today that distance can be covered in an hour and a half on Virginia's Route 15, but there is still something appealing about taking this road that is less traveled.

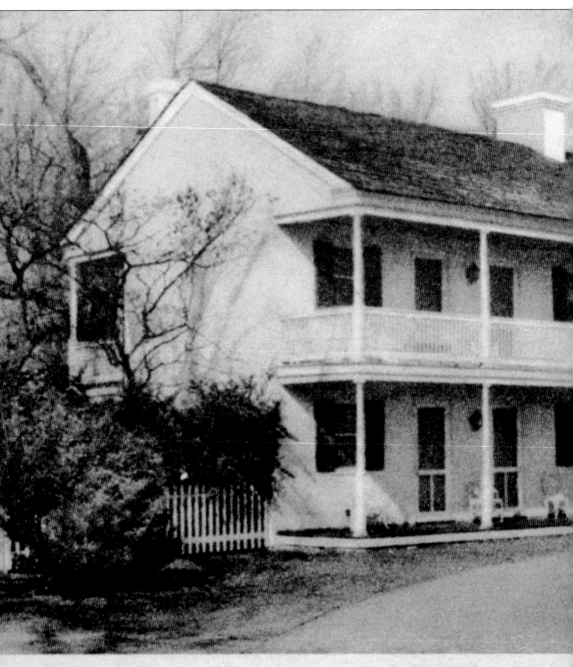

FAUQUIER WHITE

WARRENTON HOUSE NEAR WARR

Once a famous spa of the Piedmont region, Fauquier County's White Sulphur Springs Hotel was visited at different times by U.S. presidents James Monroe, James Madison, and Martin Van Buren, as well as by Supreme Court chief justice John Marshall and statesman Henry Clay. According to the Work Projects Administration guide, at its height before the Civil War, the

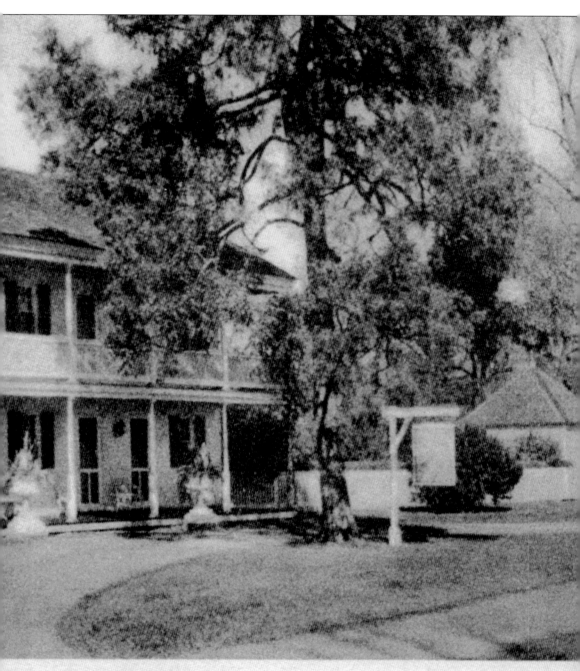

LPHUR SPRINGS

ON, VIRGINIA FOR FINE FOOD

resort could entertain as many as 600 guests at once. The complex consisted of two hotels, 90 double cabins, servants' quarters, and stables. The Virginia Assembly even sat here in the summer of 1849. This postcard identifies this building as one of the last surviving structures for the resort, which is located on Route 802 (Springs Road), southwest of Warrenton.

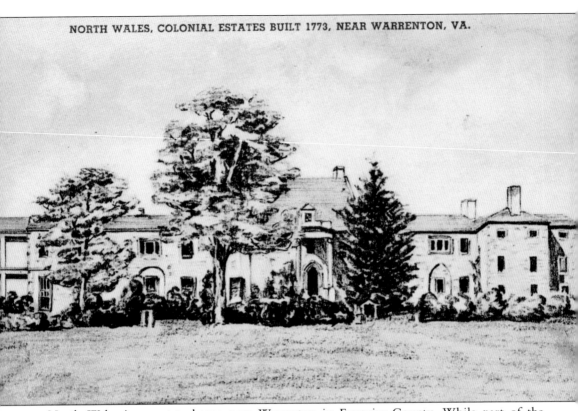

North Wales is an estate house near Warrenton in Fauquier County. While part of the house was indeed built in the late 1700s, as noted on this postcard, it was greatly enlarged by Walter P. Chrysler (of automobile fame) in 1914. The original Georgian-style structure is seen in the center portion, where the roof has its highest peak. The estate is located southwest of Warrenton off Route 802, which is known as the Springs Road or Culpeper Turnpike.

First House Built in Fauquier County at Germantown, Virginia

While the postcard identifies this structure as the "First House Built in Fauquier County," other sources have identified it as the Tillman Weaver house. Germantown, a rural community in Fauquier County off Route 28 southeast of Warrenton, was John Marshall's birthplace in 1755. The future U.S. Supreme Court chief justice is thought to have been born in a house of similar style.

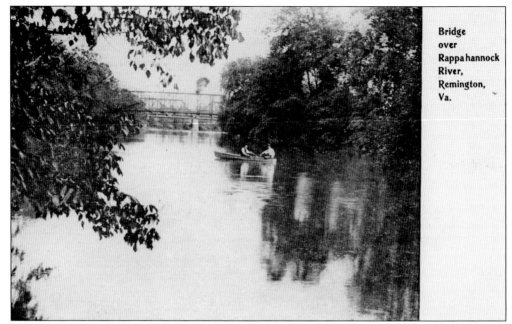

Bridge over Rappahannock River, Remington, Va.

When the railroads came through this area, the nearby depot was known as Rappahannock Station, but by 1890, the name for the village on the edge of Culpeper and Fauquier Counties had been changed to Remington. This appears to show the railroad bridge that spanned the Rappahannock River. Eventually, a bridge for U.S. Routes 15 and 29 was also located in the vicinity of the railroad crossing bridge.

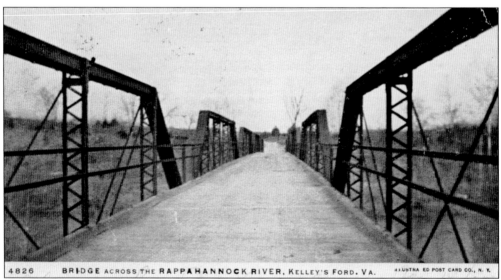

4826 BRIDGE ACROSS THE RAPPAHANNOCK RIVER, KELLEY'S FORD, VA. ILLUSTRA ED POST CARD CO., N. Y.

Kelley's or Kelly's Ford's main claim to fame is that it was the location of a Civil War engagement in which a popular Southern officer named John Pelham was killed. However, the hamlet on the Rappahannock River, just downstream from the Southern Railroad line, had been a relatively well-established community known as Kellysville for many years prior to the Civil War.

76

Three

CULPEPER
(CULPEPER COUNTY)
AND VICINITY

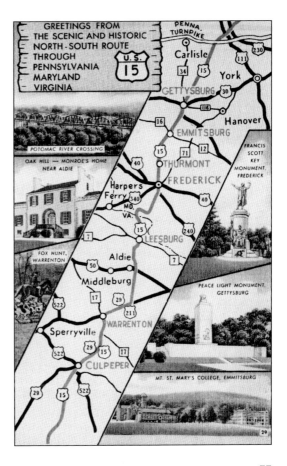

On this section of the journey along Route 15 traveling southward, one will see the town and county of the same name: Culpeper. Benefiting from its proximity to the railroad and as a crossroads for those going from east to west or from north to south, Culpeper's postcards have a more commercial flavor. Travelers from bygone days used this opportunity to send these postcards of battlefields and businesses along this stretch of highway.

Some publishers produced generic cards for an entire state and then imprinted a town's name on it to market to local merchants. Such is the case for this art deco–style postcard from the 1930s or 1940s. Culpeper is named for Virginia's 17th-century royal governor, Lord Thomas Culpeper. The county was formed in 1749 from Orange County, and the county seat was established in 1759. The town was named Fairfax from the date of its establishment until Virginia's General Assembly changed the name to Culpeper in 1870 to eliminate any confusion between the Fairfax in Culpeper County and the Fairfax in Fairfax County.

The village of Elkwood in eastern Culpeper County once was a stop for passenger trains and had a post office. That was enough for someone to design a postcard specifically for that locale. Elkwood was the name of a nearby estate, which supposedly drew its name from the red deer that early settlers would sometimes call elk. By turning off U.S. Route 15-29 at Elkwood, a visitor can reach the site of the Civil War engagement of Kelly's Ford.

This postcard could be adapted to any location; here, the greetings came from Jeffersonton. Located in the northeastern part of Culpeper County, just west of a Rappahannock River crossing, Jeffersonton is an old village named for Thomas Jefferson. Route 802 is now just a county road that passes through Jeffersonton, but at one time, it was one of the key routes from Warrenton to Culpeper and farther south. After the advent of the railroad from Alexandria through Brandy and Culpeper, road routes began to parallel the train tracks. One of these roadways developed into U.S. Routes 15 and 29 through western Fauquier and eastern Culpeper Counties.

This decorative, embossed postcard was printed in Germany and is a bit unusual because of the incorporation of the community's name into a poem. The sentiment reads, "Here I am in Brandy Station, Virginia/ Enjoying its sights and cheer/ Everything's great, and I'm feeling first-rate/ But, O, how I wish you were here." This postcard probably dates to around 1910.

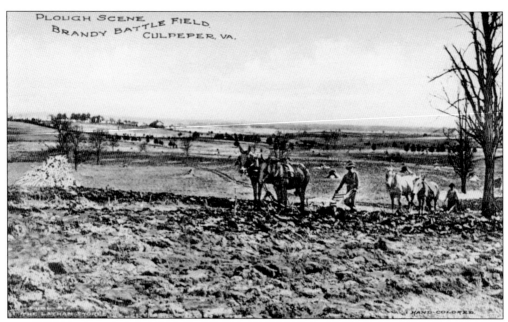

Upon crossing into Culpeper County going south on U.S. Routes 15 and 29, one will soon be in the vicinity of the village of Brandy Station. Once a stop for the railroads, now even the highway bypasses it. This postcard may have been produced to commemorate the 50th anniversary of the Battle of Brandy Station in 1913. The battle was a great cavalry clash between Confederate and Union forces. The Union army also occupied the land in this vicinity during its winter encampment in 1863–1864.

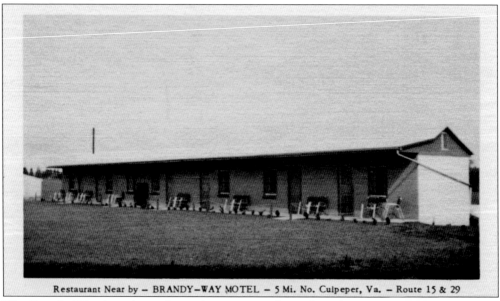

Restaurant Near by — BRANDY–WAY MOTEL — 5 Mi. No. Culpeper, Va. — Route 15 & 29

The Brandy Way Motel was located approximately midway between Brandy Station and Culpeper. In the days prior to chain motels and hotels, small roadside motor courts were the most likely places a weary family might stay overnight en route to their destination. This motel is no longer in business, but the building still stands along the original Brandy Road in Culpeper County.

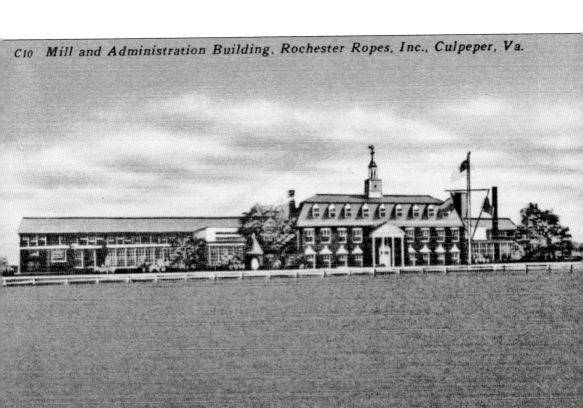

The Rochester Ropes building is a superb example of the integration of style and design into a manufacturer's building. At first glance, the original part of the plant, visible from Business Route 15 and 29, could be mistaken for a high school or college building. The landscaping in front of the building incorporated a large lawn and pond. The plant produced wire rope for a variety of applications, such as for the cables in elevators, and it shipped the wire out on spools or reels weighing hundreds of pounds. To the rear of the facility are railroad tracks to permit the deliveries to, and shipments from, the plant site.

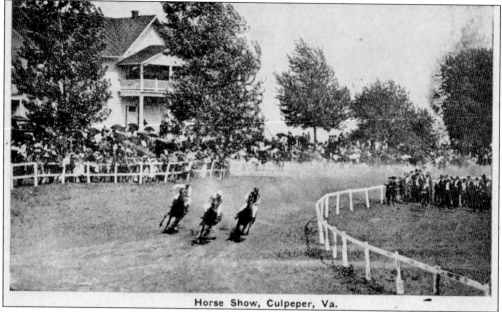

Horse Show, Culpeper, Va.

Through the first half of the 20th century, Culpeper held annual horse races at the Culpeper Fairgrounds just outside the town limits. Monte Vista Park, as it was sometimes known, was located off Brandy Road (U.S. Routes 15 and 29) east of downtown, and patrons could take a special passenger train that shuttled between the town's train depot and the fairgrounds. Crowds, some using umbrellas to ward off the July sun, cheer for their favorite steeds in the race underway in this postcard.

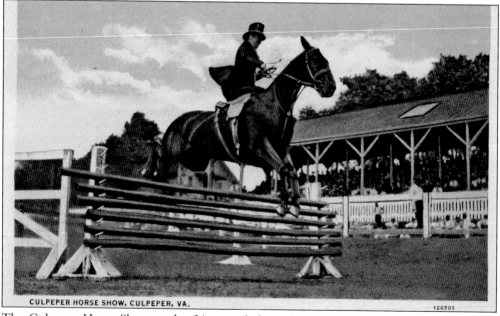

CULPEPER HORSE SHOW, CULPEPER, VA. 120705

The Culpeper Horse Show at the fairgrounds brought out crowds for the many different events. Show jumping was just one of the equestrian events. A challenging event like this was made even more challenging when a woman was competing sidesaddle, as is the case in this postcard image.

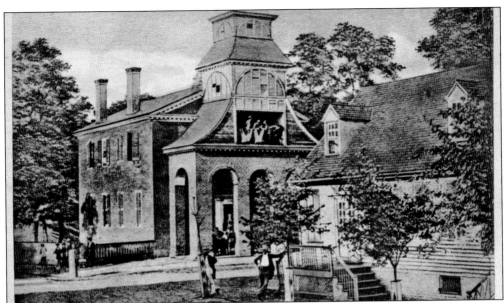

Culpeper County has had three courthouses. This was the second one, and it was constructed in the early 1800s on the site of the first one at the corner of Main and Davis Streets. This image is based on an original photograph taken during the Civil War showing soldiers in the second-story window hanging out laundry. Civil War images were popular around the time of the 50th anniversary of the war, 1911–1915. This card was mailed in June 1919, and the writer is asking whether a brother has returned home yet—perhaps a World War I soldier.

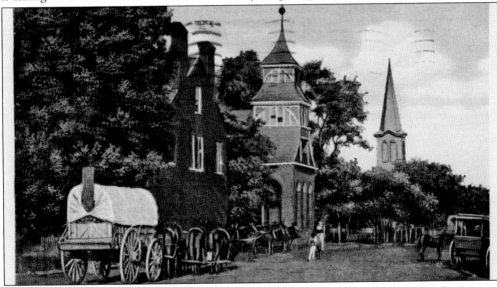

The Federal army occupied the town of Culpeper several times during the Civil War, and photographers accompanied the army as it campaigned. This image, taken during one of those occupations, was made into a postcard around the time of the 75th anniversary of the Civil War. Standing on West Davis Street near the fire station and looking toward Main Street, one would see the view of Culpeper shown here. The building with the two chimneys is the Gorrell-Hill Building on the corner of Main and Davis Streets before it was remodeled to its present-day appearance.

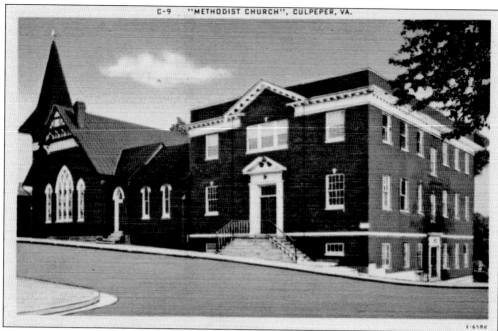

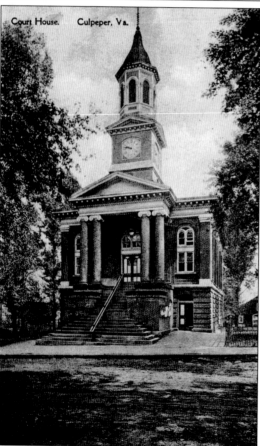

Court House. Culpeper, Va.

Directly across from the Culpeper Court House still stands one half of the old Culpeper Methodist Church. The portion of the structure shown here at the right became office space after the Methodist church moved to a larger building off U.S. Route 29. The oldest part of the church, which included the steeple portion, was torn down to make way for the Culpeper Volunteer Fire Department.

The Culpeper Court House is the dominant structure downtown. It is Culpeper's third courthouse and was completed in 1873, three years after it was authorized. It was an ambitious undertaking for this town, just five years removed from the Civil War and still in the midst of Reconstruction. The architect, Samuel S. Proctor, designed a public building dominated by red brick and white accents with wide steps leading up to the entrance. Four Ionic columns and a triangular pediment frame the front. Atop the building is a four-sided clock tower. The total cost was just under $20,000, an astounding amount for a small Southern town still recovering from war.

When the town of Culpeper decided to build the present courthouse in the 1870s, the site selected on West Davis Street allowed for a larger structure than what then existed. The adjacent lot was laid out as a town green or park. To commemorate the 50th anniversary of the Civil War, Confederate veterans and their families arranged for the construction of a Confederate memorial. The memorial was dedicated on Decoration Day, May 31, 1911. The statute's inscription reads, "Culpeper's Memorial to her Confederate Soldiers, 1861–1865, by A. P. Hill Camp No. 2 C.V., and the Citizens of this County, 1911."

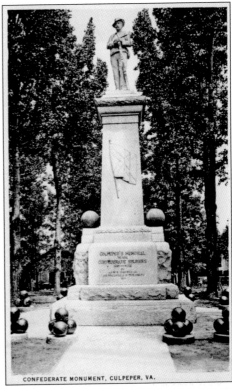

CONFEDERATE MONUMENT, CULPEPER, VA.

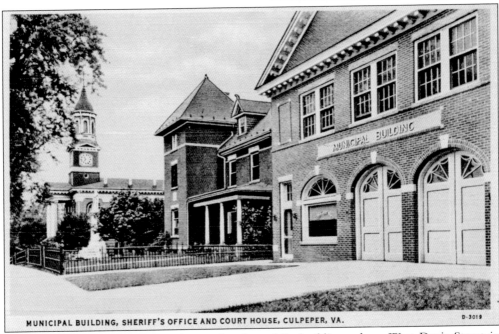

MUNICIPAL BUILDING, SHERIFF'S OFFICE AND COURT HOUSE, CULPEPER, VA. D-3019

This gives a perspective of the layout for the public buildings along West Davis Street in downtown Culpeper. It shows the town's first municipal building, the town's sheriff office and jail, the courthouse green, and finally, the courthouse itself. This view is probably from the 1930s or 1940s.

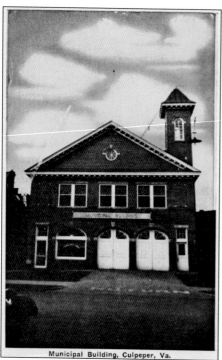

Municipal Building, Culpeper, Va.

In the 100 block of West Davis Street, just a few yards from the corner of Main and Davis Streets, sits the former firehouse and municipal office building for the town of Culpeper. Opened in the late 1920s, this building also once housed the Culpeper Town and County Library on its second floor. To the upper right, adjacent to the bell tower, one can see an early version of the streetlights that once lit Culpeper's streets. This postcard was probably published around the time of the building's opening in 1927.

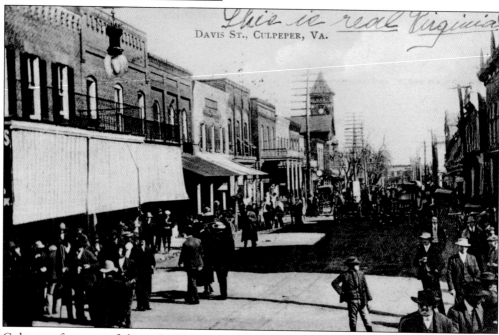

DAVIS ST., CULPEPER, VA.

Culpeper, for most of the early 20th century, remained a sleepy Southern town. A bustling street scene, as shown in this image, was unusual. Because of the number of men on the street and the absence of women, this photograph may have been taken during a court day. Quarterly court days brought the men into town for business and socializing. Farmers brought in products to sell, and horses were sold or traded. It was not considered a proper place for women since they would be mingling with the men, many of whom were also drinking and gambling.

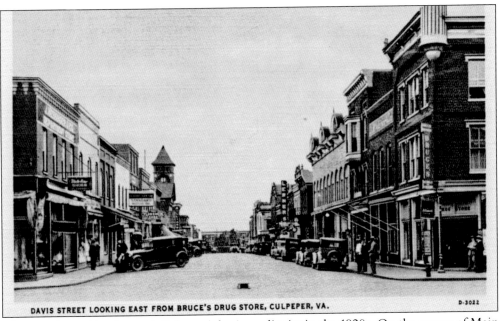

DAVIS STREET LOOKING EAST FROM BRUCE'S DRUG STORE, CULPEPER, VA.

D-3022

This is a view of the heart of Culpeper's business district in the 1920s. On the corner of Main and Davis Streets to the right sits Bruce's Drug Store (later it became Gayheart's). This postcard was produced by Bruce's and probably was sold inside the store. Farther down the right side of Davis Street, Lerner's Department Store sign is visible. Opposite Bruce's stands Messinger and Company with a shoe sign in front. There are other signs for Standard Motor Oil, Florsheim Shoes, and Dolan's Billiards. In the center of the intersection in the foreground is what appears to be a traffic control device.

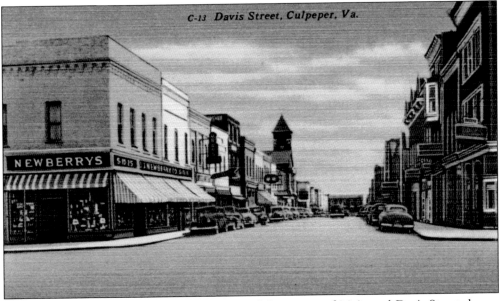

C-13 Davis Street, Culpeper, Va.

During the 1930s and 1940s, the appearance of the corner of Main and Davis Streets began to change to look like this postcard. Newberry's 5-and-10 appeared on the corner where the Civil War–era courthouse had once stood. By this time, the streets had been paved to serve the automobiles that were now the primary mode of transportation for the people of Culpeper.

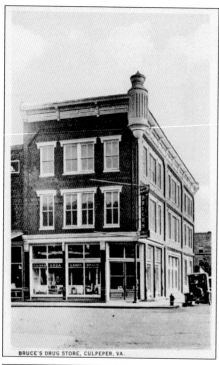

At the southeast corner of Main and Davis Streets stands this landmark. Originally called the Booton Building, it is known for its role as a drugstore, first as Bruce's and later as Gayheart's. The drugstore included the familiar soda fountain counter where townspeople and businessmen gathered to exchange news and views. One way to date this postcard is based upon the automobile visible along the Main Street side of the building, which suggests it was probably published in the 1910s or early 1920s.

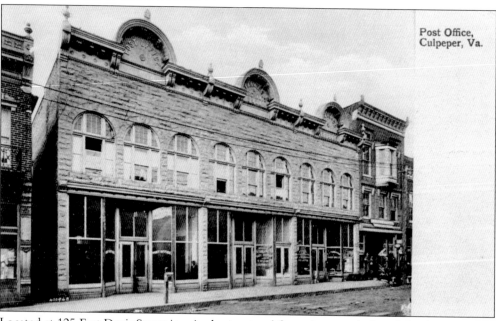

Post Office,
Culpeper, Va.

Located at 125 East Davis Street is a single structural front that was designed for three separate businesses when it was built in the 1890s. The lunettes at the roof line identify the original and first tenants as the U.S. Post Office, the Farmers and Merchants Bank, and Clark and Company Grocers. Unpaved Davis Street, in front of the post office, has stepping stones or planks for pedestrians to cross the street when it is muddy. This card is postmarked in 1908 by a R.P.O., or railway post office, usually a railcar attached to a passenger train where postal employees sorted mail en route.

This beaux arts–style building was constructed at the corner of Davis and East Streets in 1902. Known as the Masonic Temple for Fairfax Lodge No. 43, Ancient Free and Accepted Masons, the street level has been used for different businesses during the building's history. At the time this postcard was published, Goodloe's occupied the retail portion of the building. Owned by businessman Archie L. Goodloe, the store sold men's wear and dry goods.

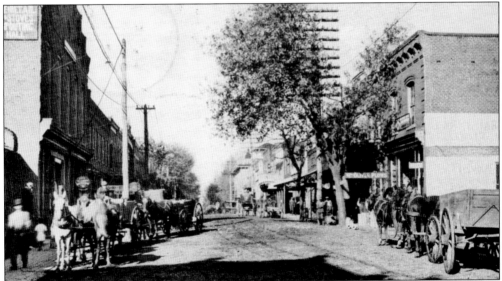

Davis Street was the heart of the historic commercial district for many years. This 1912 postcard shows Davis Street looking westward from the corner of East and Davis Streets toward Main Street. To the left is the Old Armory/Yowell Hardware building, and to the right is Central Hardware (with the Oliver Plows sign). No automobiles are seen, and the street is lined with trees and utility poles. In 1888, Culpeper enacted building codes after a fire destroyed several downtown frame buildings. Buildings were required to have brick or stone walls and slate or metal roofs to minimize the fire risk. This decision by the town council minimized the damages in future fires.

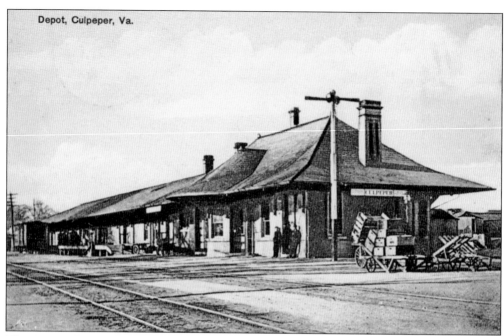

Depot, Culpeper, Va.

The 1904 Culpeper train depot was the focal point for travelers and commerce for the town of Culpeper for many years, until passenger service declined in the 1970s. An earlier Civil War station was located in the same general vicinity at the east end of Davis Street.

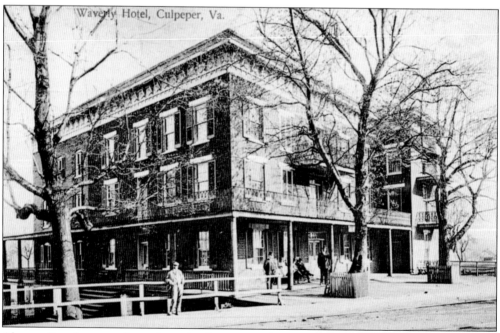

Waverly Hotel, Culpeper, Va.

Almost directly across from the train depot in Culpeper was the Waverly House or Waverly Hotel. It was razed in the 1970s, but during the heyday of passenger travel on the railroads, it was the place for railroad passengers to eat and rest up from their travels.

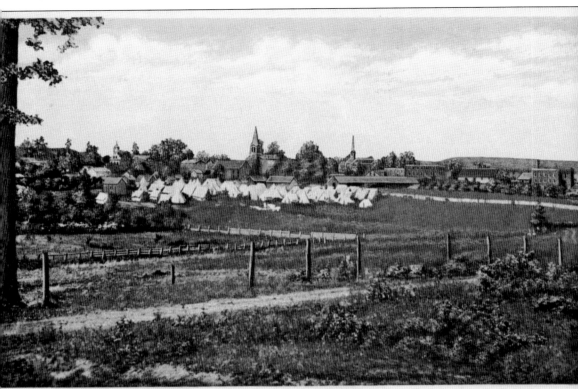

GRANT'S ARMY IN CAMP AROUND CULPEPER DURING CIVIL WAR 1863 120696

Civil War commemorative postcards were popular around the 50th (1911–1915) and 75th (1936–1940) anniversaries of the Civil War. Some, like this postcard, were reproductions of images taken by Civil War–era photographers. The town of Culpeper would have appeared this way to someone standing on the hills east of the railroad tracks looking northwest. The location of the tents is approximately where the National Cemetery is located today in Culpeper.

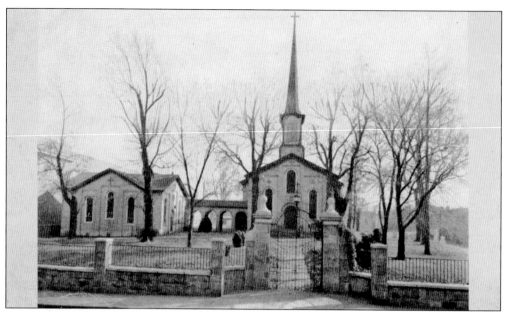

St. Stephen's Episcopal Church, located at 115 North East Street, is probably second only to the Culpeper Court House as a landmark and recognizable feature of the Culpeper skyline. Built in the early 1820s in a Gothic Revival style, the church's spire appears in many Civil War photographs taken by photographers who accompanied the Union army during its occupations during the course of the Civil War.

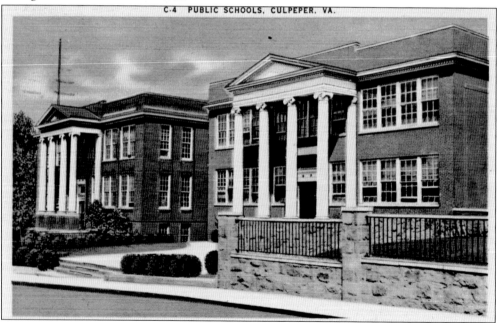

C-4 PUBLIC SCHOOLS, CULPEPER, VA.

Adjacent to St. Stephen's Episcopal Church in the 100 block of North East Street, Culpeper County constructed a series of public schools. Together they were known as the Ann Wingfield School. At the time this postcard image was made, probably in the 1940s, the older of the two structures is the one to the left. Eventually, it was torn down to make a parking lot for the other building, which was converted into apartments.

Piedmont Street, Culpeper, Va.

This is the view a visitor arriving from the east would have when entering the town of Culpeper. For many years, the primary route into town from the Brandy area was via the Old Brandy Road to Piedmont Street. Main Street was a dead end at Mountain Run. Traffic would come and go along Piedmont Street toward the village of Brandy Station. On old highway maps, this stretch of Piedmont Street was the original route for U.S. Routes 15 and 29.

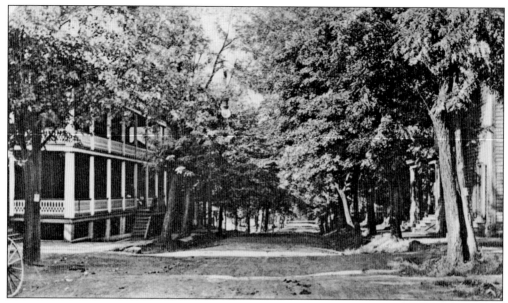

For anyone who has traveled in Culpeper, this view is almost unrecognizable, despite the fact the building to the left still stands. This view is of the 200 block of North Main Street, and the Old Virginia Hotel is the structure to the left. Originally built in the early 1800s, this historic building was occupied by both Confederate and Union troops at various times during the Civil War. Across the street is the Shackelford House, where Confederate major John Pelham was taken to die after being wounded at the Battle of Kelly's Ford in 1863. The tree-lined streets and the Shackelford House are now gone, but the history remains.

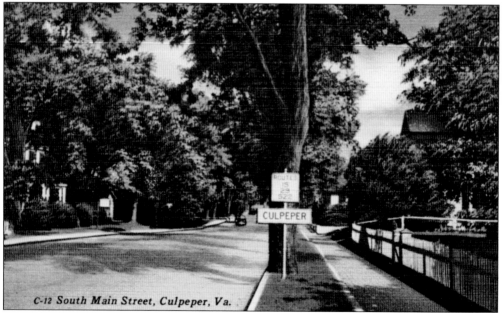

C-12 South Main Street, Culpeper, Va.

This postcard image was used in a publicity campaign by the Culpeper Chamber of Commerce in the 1940s. Highlighting its position as having "A Highway in All Directions," Culpeper hoped to lure businesses that would take advantage of its central location and the quality of the land and people.

94

EAST STREET, CULPEPER, VA.

The most architecturally significant set of residences in Culpeper is found along East Street. Despite their beauty and character, almost no postcards seem to have been made showing these homes. This is one exception, and, as can be seen, the homes are not visible because of the extensive tree cover. Many of Culpeper's streets were tree-lined for many years, but the need to widen the streets for two-way automobile traffic and sidewalks led to the demise of the trees along the streets' shoulders.

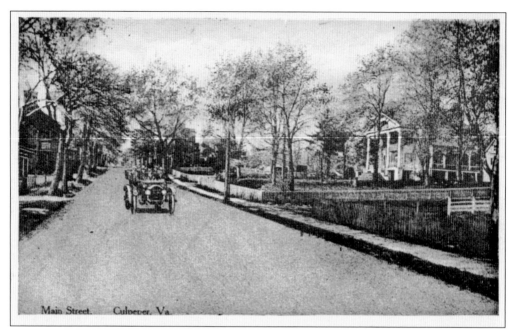

Based upon the features visible in this street scene, this is probably the 300 block of Main Street in Culpeper. The house to the right was the home of William "Extra Billy" Smith, which was torn down in the 1920s to make way for the U.S. Post Office building. For travelers along Route 15 in the early 1900s, this would have been a familiar view.

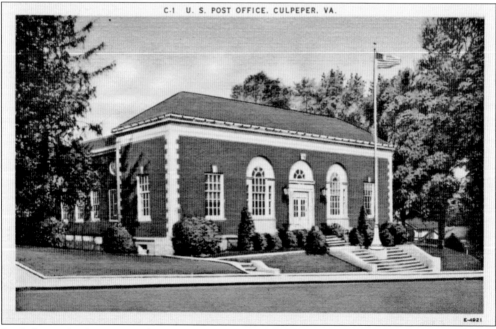

In Culpeper in the 1930s, a large estate house was torn down to make way for this post office, located at 302 North Main Street. The home had been once owned by William "Extra Billy" Smith, who made at least one of his many fortunes running a stagecoach service through part of the South prior to the arrival of passenger trains.

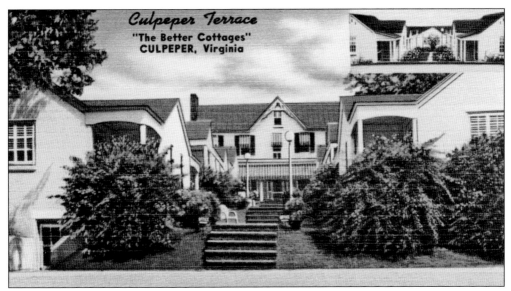

The Culpeper Terrace Motel is an example of the style of cottage motels that became popular as automobile travel became more prevalent in the 1930s and 1940s. Families stayed in single units and parked off Main Street in a lot built for the motel. This motel was in the 400 block of North Main Street adjacent to the original Precious Blood Catholic Church. Since the 1980s, the church and the motel were torn down to make way for a larger Catholic church that now occupies the entire block fronting Main Street.

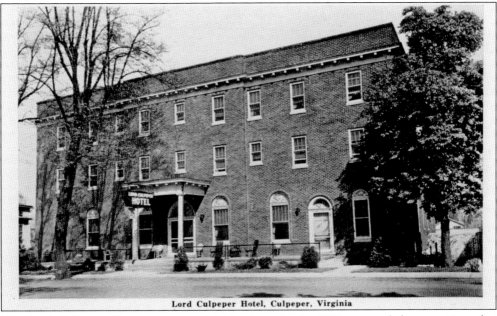

Lord Culpeper Hotel, Culpeper, Virginia

The Lord Culpeper Hotel was opened for business in the 1930s, around the same time that the Shenandoah National Park, 30 miles away, opened. Advertising brochures for the Lord Culpeper say it offered "modern hotel service" and had "running water in every room." It no longer serves as a hotel, but the building, located at 401 South Main Street, looks remarkably the same as when this photograph was taken. Bayard Wootten, a pioneering female professional photographer from North Carolina, produced this image.

Just off of Culpeper's East Street is Culpeper National Cemetery, which is maintained by the Veterans Administration. Established after the Civil War, there are close to 1,400 Union troops buried here who died on various nearby battlefields, including at Brandy Station and Cedar Mountain. Few Confederate soldiers are buried in any national cemetery. They are ineligible due to their participation in armed insurrection against the government of the United States.

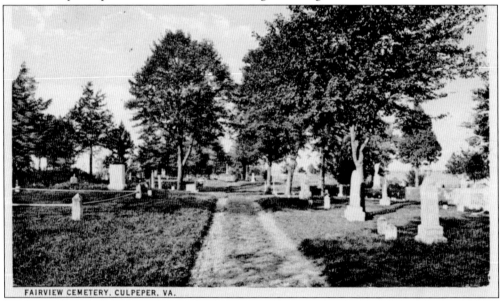

FAIRVIEW CEMETERY, CULPEPER, VA.

Fairview Cemetery, located on Route 522 one mile west of Main Street, is a beautiful, historic cemetery maintained by the Town of Culpeper. Among those buried here are approximately 400 unknown Confederate soldiers killed in various battles around the county. The marker for those graves was erected in 1881, the 20th anniversary of the war's start. In 1903, the Culpeper Town Council officially segregated Fairview Cemetery, which led to the establishment of the African American Antioch Cemetery adjacent to, but separate from, Fairview Cemetery. In 1970, the adjacent Antioch Cemetery was merged with the municipal cemetery, and the unified cemetery is now listed on the National Register of Historic Places.

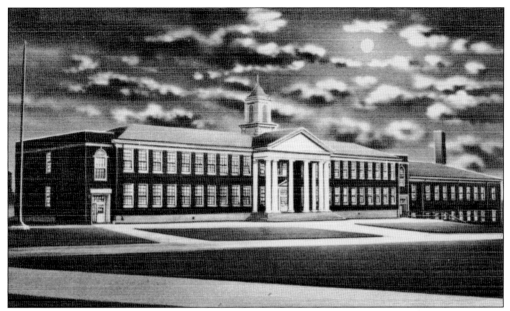

This postcard certainly presents the Culpeper High School in a different light—moonlight! The new high school was opened in 1949, but only white students were permitted to attend because Culpeper did not fully integrate its school system until the mid-1960s. The Culpeper Chamber of Commerce, in the 1940s, promoted it as a "Comprehensive High School offering: college preparatory, agricultural and farm shop, home economics, full commercial, general shop trades, distributive education, music, art."

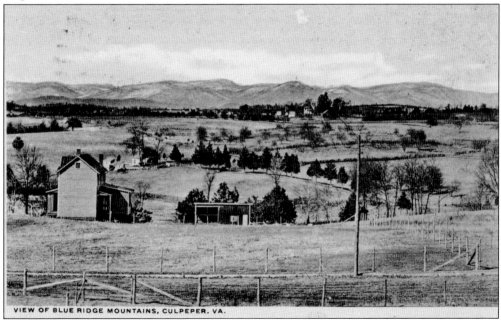

VIEW OF BLUE RIDGE MOUNTAINS, CULPEPER, VA.

There are places in Culpeper where the nearby Blue Ridge Mountains cannot be seen, but in other spots one can almost reach out and touch them. The town of Culpeper has an aptly named Blue Ridge Avenue that may have been the location for this shot. There are vistas on the west side of the town that showcase the lovely rolling hills of the Piedmont countryside.

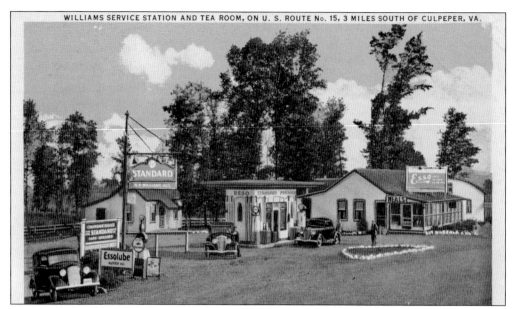

The Tea Room was south of the town of Culpeper on U.S. Route 15. Visitors could fill up with Esso gas as they approached from the south or grab a quick bite. The postmark on this card is 1933, but the hard times of the Great Depression did not diminish interest in tearooms. Essentially, small roadside restaurants, or tearooms, filled car travelers' needs for food between towns. Their heyday was during Prohibition, when selling alcohol was prohibited; tearooms were considered reputable places for both men and women to stop.

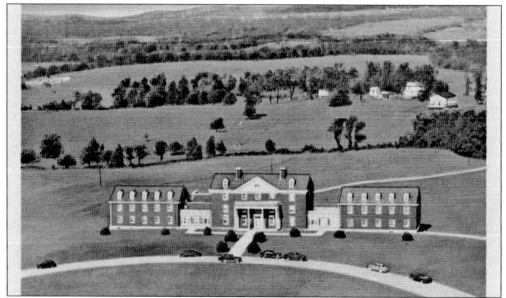

To the citizens of Culpeper, the Baptist Home for Aged is more familiarly known as the Baptist Home. Built in a Georgian style in the early 1950s, this retirement home provided a place for the elderly. Postwar America saw a change in the family; it was no longer assumed that those over the age of 65 would be cared for by family members. A retirement home became a more acceptable option for many. Today such facilities are taken for granted, but at the time of its construction, the Baptist Home was one of the first of its kind in Virginia.

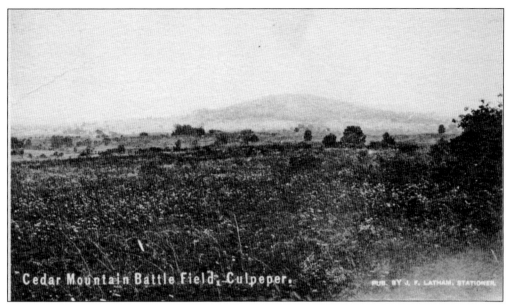

Cedar Mountain Battle Field, Culpeper.

PUB. BY J. F. LATHAM, STATIONER.

This postcard was mailed in January 1907 to Rhode Island. Because the inscription reads that the traveler has been to "Norfolk, Petersburg, Fredericksburg, Orange, etc.," it is likely the person was traveling by train, as all of these towns had train service. Cedar Mountain Battlefield is located a few miles south of the town of Culpeper along Route 15, and the railroad line runs to the east of the mountain and the battlefield area.

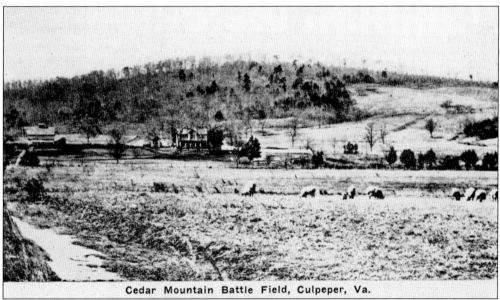

Cedar Mountain Battle Field, Culpeper, Va.

This pastoral scene of grazing sheep and melting snow along a fence line belies the hostilities that occurred on this land in a hot August in 1862. Cedar Mountain (also Slaughter's Mountain or Cedar Run) was an intense battle that has been overshadowed by larger campaigns. Still, there was a general recognition of the battle's significance, which is shown by the many postcards produced of the battlefield around the commemoration of the 50th anniversary of the Civil War. The battlefield, along Route 15 south of Culpeper, remains remarkably similar to this view.

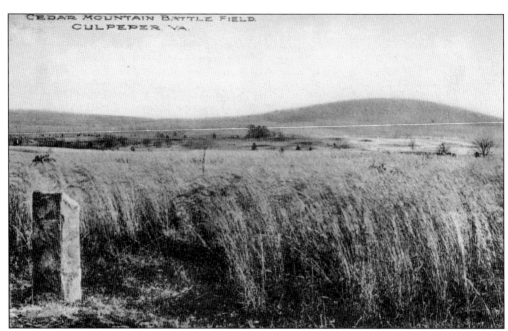

Cedar Mountain Battlefield in Culpeper County had been generally known to local residents and history buffs, and a few battlefield markers were erected, but it was not part of the national park system. Luckily, this battlefield did not suffer from the widespread development that enveloped so many of Virginia's battlefields in the 50 years since the Civil War's centennial. Today groups of preservationists work diligently to preserve the landscape so that it will look the same as it did on this postcard from the 1910s.

While Virginia had segregated elementary schools until the 1960s, there were few high schools for black students to attend. By the 1940s, Rappahannock, Madison, Orange, and Culpeper Counties began to establish a "[r]egional Negro vocational high school . . . to house 500 pupils, located 7 miles south of town of Culpeper on Route 15, on 11 1/2 acre plot of land." The Culpeper Chamber of Commerce projected George Washington Carver High School would cost $400,000 to build. While no longer a public school, the building is used for training programs, and it continues to serve as a reminder of segregation.

Four

ORANGE (ORANGE COUNTY) AND POINTS SOUTH

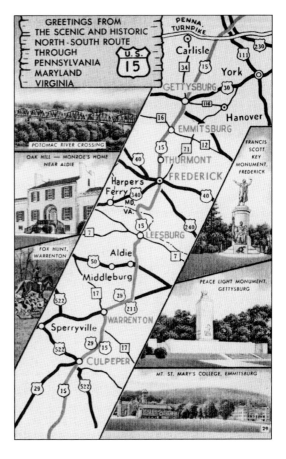

This final section of the journey leads south on Route 15 and on Routes 231 and 20. The countryside of Orange and Albemarle Counties is the province of presidents. Thomas Jefferson, James Monroe, John Taylor, and Theodore Roosevelt have all traveled these roads. Travelers from bygone days used this opportunity to send postcards of Orange, Gordonsville, and Cismont, as well as of Monticello and Ash Lawn.

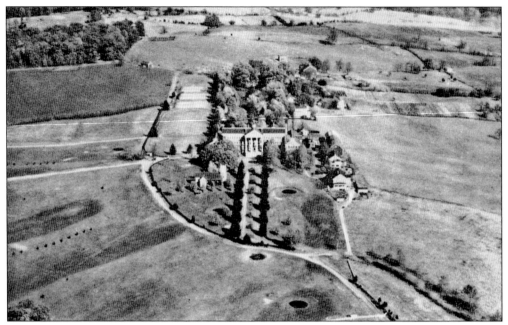

Located on the former estate of William Madison, brother of James Madison, Woodberry Forest was established as a private boys' school in 1889. This early aerial view of the school and its golf course shows the expanse of land surrounding the campus. Located in the southeast corner of Madison County along Route 15, this lovely, rolling land was a beautiful site for a school. Woodberry Forest now has more buildings than existed at the time of this postcard, and it is still just as spectacular.

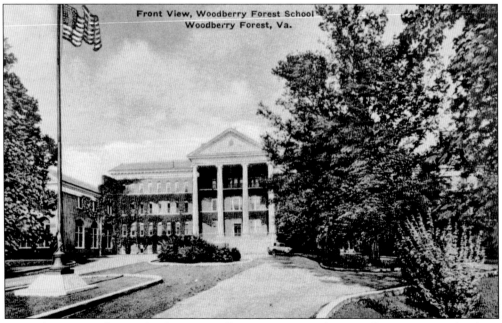

Located just six miles north of Orange off U.S. Route 15, the Woodberry Forest School sits on more than 1,200 acres in Madison County. The Walker Building is named for the school's founder, who was a former member of Mosby's Rangers in the Civil War.

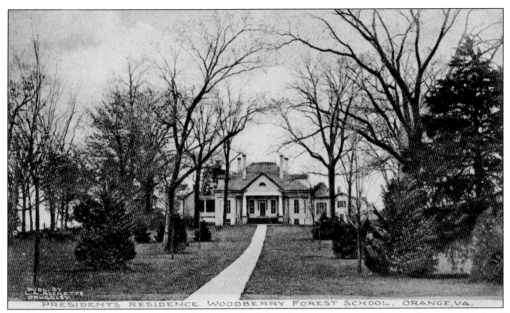

The hand of Thomas Jefferson is believed to be behind this architectural gem on the grounds of the Woodberry Forest School, located just north of Orange. Originally built in the late 1700s for James Madison's brother, the home became the headmaster's house when the Woodberry Forest School started. By the time this image was made, almost 25 years after the school's founding, it was the school president's residence.

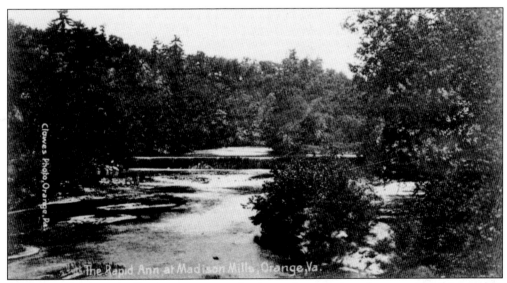

This wonderful card tells an interesting tale about the vagaries of names. This river is the boundary of Madison and Orange Counties at a tiny village known as Madison Mills along Route 15. On all modern maps, the river is named the Rapidan, but as can be seen in this caption, the local population also had an alternate name for this tributary, the Rapid Ann. It originates in the Blue Ridge Mountains and serves as the boundary line for several counties. As it continues flowing from this point at Madison Mills, the Rapid Ann (or Rapidan) eventually joins up with the Rappahannock River, and they flow as one toward the town of Fredericksburg.

Located to the south of Culpeper County along U.S. Route 15, Orange County was formed in 1734. The county and town were named to honor William IV, the Prince of Orange (Netherlands), who had married Princess Anne, the daughter of British king George II, that same year. The town of Orange is the county seat.

Montebello, Home of Mrs. Leslie H. Gray, Orange County, Virginia

Montebello, located to the north of the town of Orange along Route 15, has long been a familiar landmark. The earliest part of the home was built around 1740s, with many additions and modifications in the years thereafter. During the Civil War, parts of the Confederate army camped on the estate's grounds, and supposedly Gen. Robert E. Lee and officers on his staff were entertained in the home. Besides the home itself, the estate was long known for its boxwood gardens, which were laid out and terraced sometime in the 1700s.

106

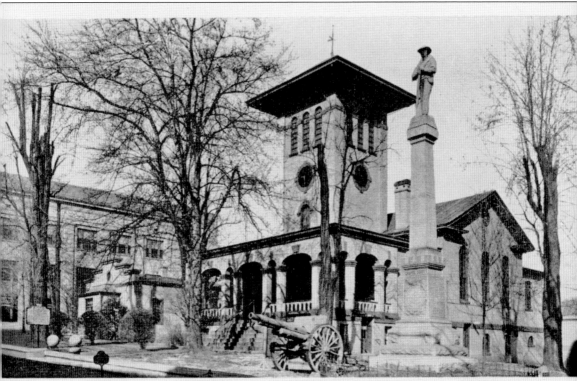

Orange County Court House and Confederate Monument, Orange, Virginia

At the corner of Madison Road (U.S. Route 15) and Main Street stands a graceful Italian villa–style building designed by Washington, D.C., architects Haskins and Alexander. It is Orange County's courthouse, constructed in the late 1850s. This is a unique public building for Virginia, since so many local communities adopted more traditional Colonial or Georgian styles for their courthouses. According to the Historic Landmarks Commission, there was a time in the 19th century (before air-conditioning) when some architects thought the Italian villa style would work well in the hot Southern climate. However, there are few examples of this style found in Virginia.

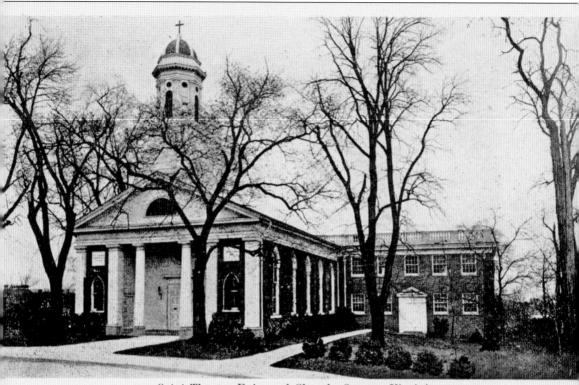

Saint Thomas Episcopal Church, Orange, Virginia

Historical research suggests that St. Thomas Episcopal Church in Orange may have been based on plans drawn up by Thomas Jefferson shortly before his death for another church in Charlottesville. Even if that is not the case, this 1830s church still has a storied past. It served as a hospital and a place of worship for Confederate soldiers during the Civil War. The congregation has preserved the pew in which Gen. Robert E. Lee sat many Sundays in the winter of 1863–1864. The church also has a Tiffany stained-glass window that was installed during a renovation in the late 1800s. Bayard Wootten took this postcard image. An often-overlooked North Carolina female photographer, Wootten traveled across Virginia and North Carolina in the 1930s taking pictures for postcards. As in this example, she often did not receive credit for her work.

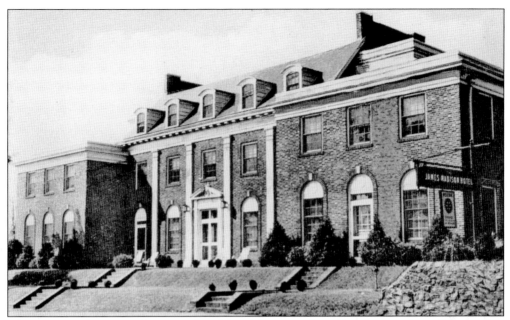

The James Madison Hotel promoted itself on this postcard as a "modern version of Montpelier, James Madison's home in Orange." The hotel is located at 120 Caroline Street in downtown Orange, within walking distance of the train depot and just a block off Routes 15 and 20. It was built in the late 1920s in an area and at a time when the growing numbers of travelers had few options for overnight accommodations.

Small towns depended on their volunteer fire departments, and the firehouses were often located near the business district to ensure the quickest response to a fire that might destroy the commercial heart of a community. Orange had already learned a painful lesson in 1908, when part of the downtown area was destroyed by fire. Just a block away from the Orange County Court House, the Orange Volunteer Fire Company Building was built in 1938 at 137 West Main Street.

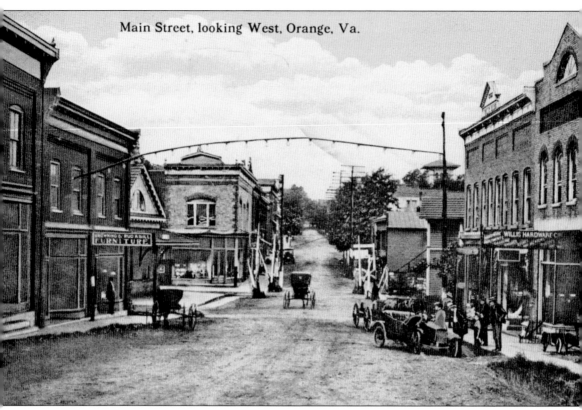

Main Street, looking West, Orange, Va.

This view looking west along Orange's Main Street shows the historic commercial district for the town. The railroad runs directly across Main Street, and a railroad crossing sign is visible in this view to the right midway down the street. Against the sky, the Orange County Court House's tower is visible. The postmark on this card is 1917, and it provides a glimpse of the world as it was changing for Orange. On the street, people are gathered around the horseless carriage in front of Willis Hardware Company, while a horse-drawn carriage rolls down the street without drawing any attention. The town of Orange also had installed arched streetlights in its commercial district.

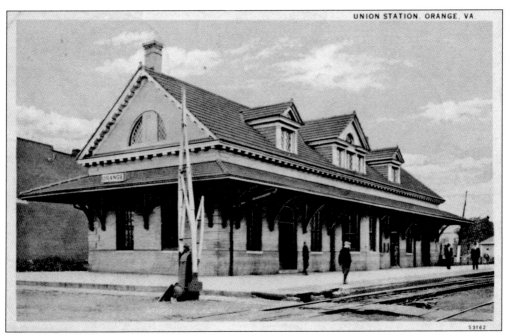

Soon after a devastating fire in the downtown Orange business district destroyed the previous train station, this new Southern Railroad depot was built in 1909 at 122 East Main Street. The last passenger train stopped in Orange in the 1970s, and the town government converted the building into a center for the community's tourism efforts.

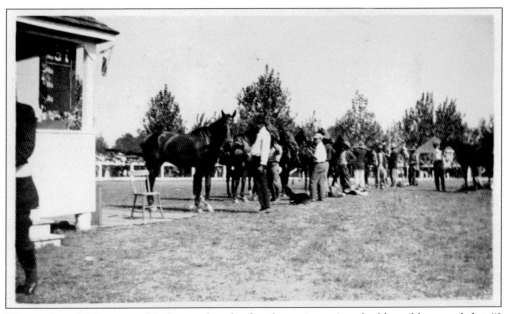

The sender of this postcard indicates that the first horse is getting the blue ribbon, and that "I am going to bring the horse and ribbon home." Since the card was postmarked in Orange in August 1911, it is probably a view of the Orange County Horse Show of that same year.

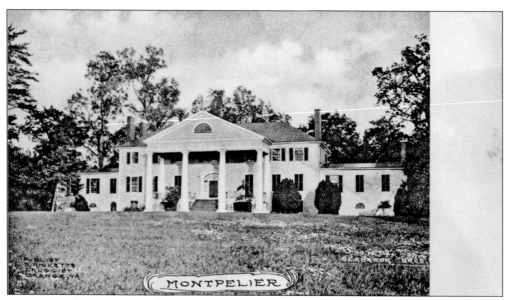

Montpelier, former U.S. president James Madison's home, was privately owned for many years and was not open to the public except for visits to the Madison family cemetery. Now under the stewardship of the National Trust for Historic Preservation, the Madison home is open to visitors. It was the subject of many postcards during the early 1900s. This view shows the original portions at the heart of the mansion.

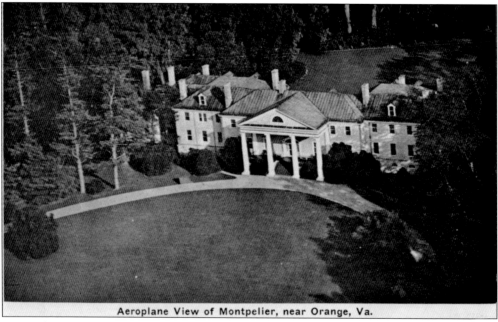

Aeroplane View of Montpelier, near Orange, Va.

Montpelier was owned by members of the duPont family from 1901 to 1983. They maintained the integrity of the heart of the Madisons' home, but they also added to the wings, as can be seen by comparing the two images on this page. The postcard above probably dates to around 1906, while this aerial view is probably from the 1930s, after the additions were made. These views are of the front of the home that faces west toward the Blue Ridge Mountains. Restoration has returned the mansion to the general appearance it had after 1812.

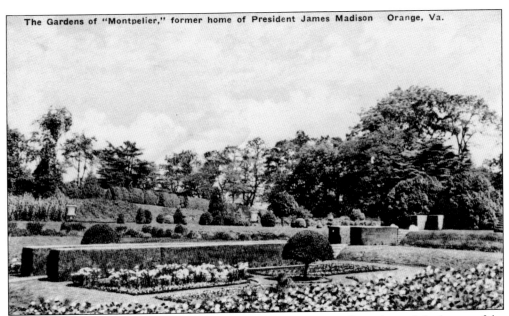

The Gardens of "Montpelier," former home of President James Madison Orange, Va.

According to the Garden Club of Virginia, this garden at Montpelier mirrored the layout of the Hall of the House of Representatives in the U.S. Capitol. When this postcard of Montpelier's gardens was published, they were under the care of the duPont family. The estate also contains 200 acres of old-growth forest that has been designated as a National Natural Landmark by the Department of Interior. The Madisons arranged for this forest to be preserved, making it a unique stand of trees in the Piedmont.

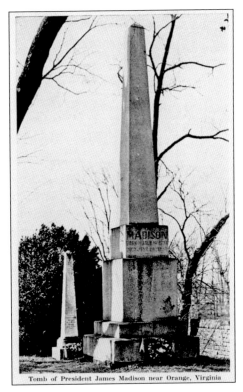

James Madison's tomb on the grounds of Montpelier in Orange County was photographed by North Carolina photographer Bayard Wootten, probably in the 1930s. Wootten was a female photographer in the days when few women were in that profession. To supplement her income during the Great Depression, she traveled around Virginia's Piedmont taking photographs that could be made into postcards. She took a number of pictures of buildings and places in Orange that ended up gracing postcards like this one.

Tomb of President James Madison near Orange, Virginia

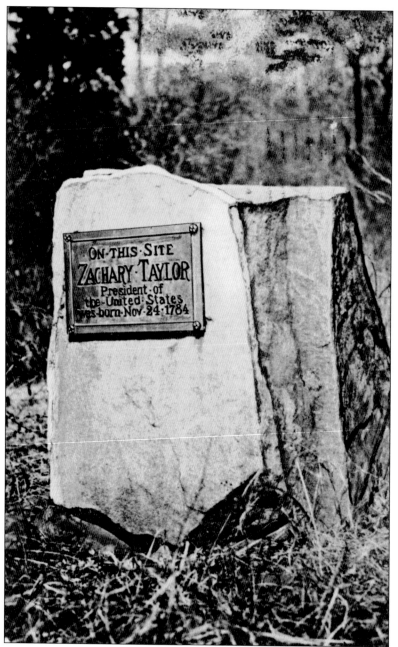

On the 150th anniversary of U.S. president Zachary Taylor's birth in 1934, this postcard was mailed from Orange. The stone marker reads, "On this site Zachary Taylor, President of the United States was born Nov 24, 1784." Zachary Taylor, 12th president of the United States and a hero of the Mexican War, was born in 1784 in Orange. That much is not in dispute, but there are different sources that place the location of his birth in various spots in Orange County. The confusion seems to have arisen from the fact the Taylor family was leaving Orange County, heading west, when he was born. Many authorities believe his birthplace was most likely in the Barboursville area, southwest of the town of Orange and approximately three miles west of Gordonsville on U.S. Route 33.

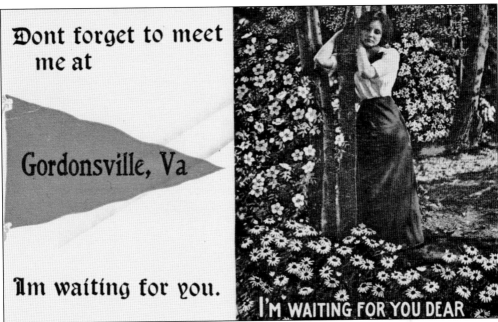

For many single, young people of courting age, nothing was more fun or exciting than receiving a postcard like this one. It was mailed from Gordonsville to Josie Grubbs in Lexington, Kentucky, in 1913. The young man who sent the card had not been feeling well and mentions that they had snow and more was on the way, but he sure was glad to have recently received a card from Josie.

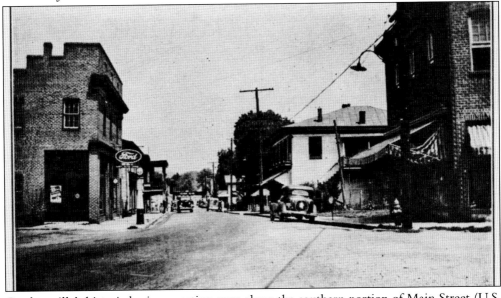

Gordonsville's historic business section runs along the southern portion of Main Street (U.S. Routes 15 and 33). As a once-thriving transportation hub at a crossing point for roads and railroads, Gordonsville's fortunes have ebbed and flowed with those of the railroads. This postcard shows a scene possibly in the late 1920s or early 1930s, when automobiles had become firmly established as the means of transport and the street had been paved. Fire destroyed this section of town in 1916 and 1920, so many of the buildings in this view are new.

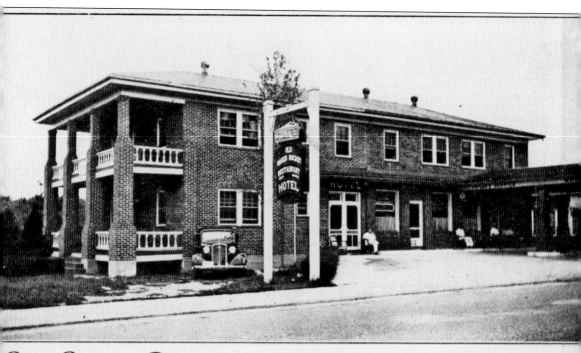

Old Oaken Bucket

GORDONSVILLE VA.

RESTAURANT

HOTEL

BEST HOME COOKING
HEATED ROOMS
FRIED CHICKEN
COUNTRY HAM

The Old Oaken Bucket owes its name to an 1818 Samuel Woodworth poem entitled "The Old Oaken Bucket," which was once so popular that children memorized it by heart and it was set to song. This structure, which still stands in Gordonsville along the 200 block of Main Street, started its life as a restaurant and hotel. It opened to the public on January 1, 1931, during some of the hardest times of the Depression. Because of its location within an easy walk of the train depot, it could draw overnight guests from both the passenger trains that stopped in Gordonsville and from the increasing numbers of automobile travelers passing through on U.S. Routes 15 and 33. The back of the postcard indicates that they did it all—"Gas, oil, car washing, polishing, wrecking service, general auto repairing, welding, brazing, etc."

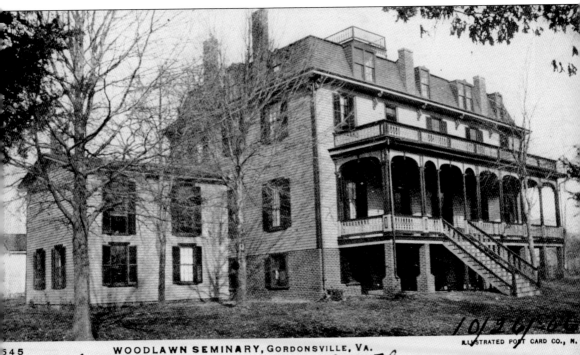

This grand Victorian building in Gordonsville was known as the Woodlawn Seminary when this postcard was mailed in 1906. Previously, it had been a series of girls' schools, starting first as the Gordonsville Female Institute in 1878. Orange County eventually bought the building and converted it to a public school, operating it for a time as the Gordonsville High School. It was torn down in the 1960s to make way for the Gordon-Barbour Elementary School, located off of Route 231 at Wright Street.

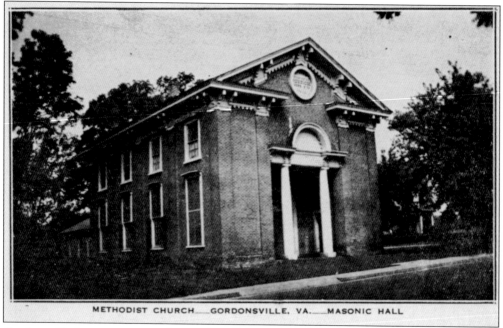

METHODIST CHURCH___GORDONSVILLE, VA.___MASONIC HALL

Gordonsville has some extraordinary churches, of which the Gordonsville Methodist Church is one example. Located in the 400 block of North Main Street (Routes 15 and 33), this 1873 brick structure has its date of construction inscribed in the circle at the apex of the front. The second story of the building was leased to the Waddell Lodge No. 228 of Ancient, Free, and Accepted Masons, leading to its secondary purpose as a Masonic hall.

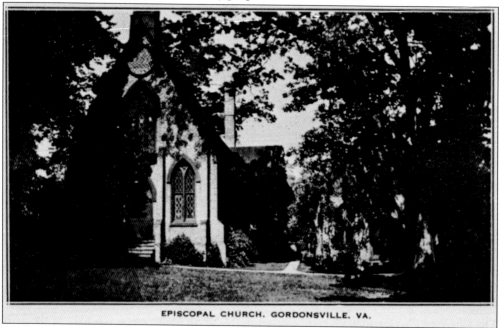

EPISCOPAL CHURCH, GORDONSVILLE, VA.

Christ Episcopal Church, located at 310 North High Street in Gordonsville, is a lovely Gothic brick church that was built in the 1870s. This postcard was probably published in the 1920s or 1930s, and the trees and shadows conceal the special attributes of the church's design.

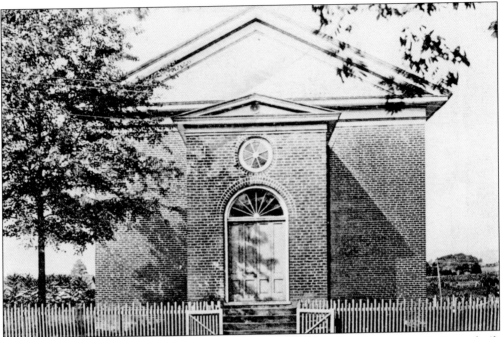

Sadly, the Gordonsville Baptist Church, shown in this postcard, no longer stands. It was built at 503 North Main Street around the time of the Civil War and was torn down for a parking lot in the early 1970s. Circular windows on the front and sides gave light and character to the vestibule that extended from the front of the building. The basement of the church was used for treating Confederate wounded at various times during the Civil War.

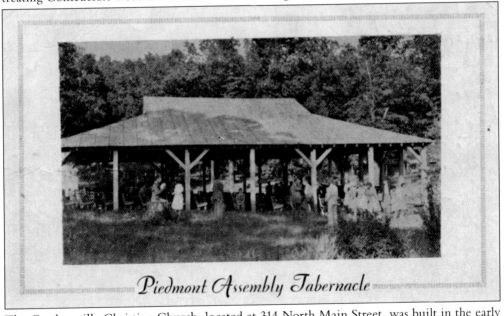

Piedmont Assembly Tabernacle

The Gordonsville Christian Church, located at 314 North Main Street, was built in the early 1850s. Beginning in 1899, the church held annual meetings at the tabernacle grounds, which were located west of Gordonsville near the train tracks. Thousands would come to the listen to speakers and attend prayer sessions during the weeklong summer events.

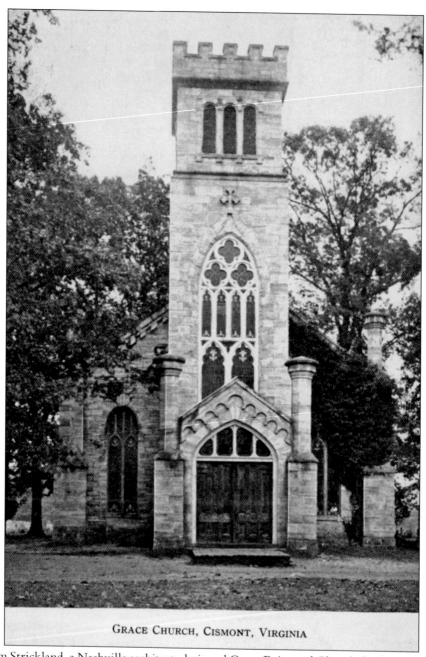

GRACE CHURCH, CISMONT, VIRGINIA

William Strickland, a Nashville architect, designed Grace Episcopal Church for the parishioners of Mark's Parish near Cismont in the mid–1800s. Modeled in the Gothic style and reminiscent of medieval English churches, it survived the Civil War, but a fire destroyed much of the interior in the 1890s, and it had to be remodeled. This postcard probably dates to around 1910. Cismont, located on the scenic byway of Route 231 (the Blue Ridge Turnpike) southwest of Gordonsville in Albemarle County, is a small community in horse country. Since 1929, Thanksgiving at Grace Church has been the traditional time for the colorful service known as the Blessing of the Hounds, where foxhunters, their horses, and their hounds gather for a ceremony of prayer and thanksgiving for the upcoming foxhunt and for the harvest.

This postcard of James Monroe, mailed in 1907, was part of a commemorative series on the American presidents. Because photography had not yet been developed, presidents before John Quincy Adams (the first to be photographed) are only known through their portraits. This engraved image is surrounded by an embossed golden eagle and a red, white, and blue flag. From the late 1790s until Oak Hill was built, Monroe maintained his private home at Ash Lawn near his friend and mentor, Thomas Jefferson. Of the first five presidents, three died on the Fourth of July: John Adams and Thomas Jefferson in 1826 and Monroe in 1831.

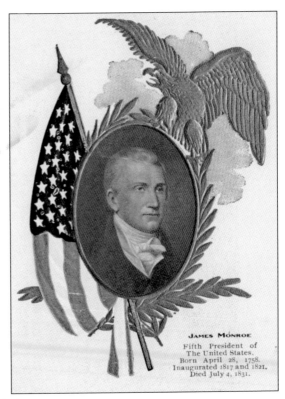

JAMES MONROE
Fifth President of
The United States.
Born April 28, 1758.
Inaugurated 1817 and 1821.
Died July 4, 1831.

JAMES MONROE
1758-1831

Ash Lawn was James Monroe's home in Albemarle County. As stated on the reverse of this postcard, the house "was planned for him by his friend and neighbor Thomas Jefferson and built in 1798 within three miles of Monticello." This statute of former U.S. president James Monroe was placed at Ash Lawn in 1931 on the 100th anniversary of his death. The Venezuelan government donated the statute, made by sculptor Attilio Piccirilli, to honor the Monroe Doctrine, which helped protect Venezuela during U.S. president Grover Cleveland's administration.

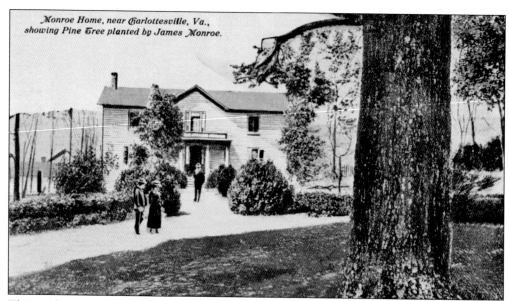

Monroe Home, near Charlottesville, Va.,
showing Pine Tree planted by James Monroe.

This card commemorates the Norwegian pine that was planted during James Monroe's years living at Ash Lawn. He brought the exotic tree back from Europe after serving as ambassador. Reports of the time say he placed the pine in the center of his garden, but this postcard does not appear to support that story. Monroe designed his boxwood gardens by integrating American and European principles, with the result being a garden that tourists sought out upon their visits to his Charlottesville home.

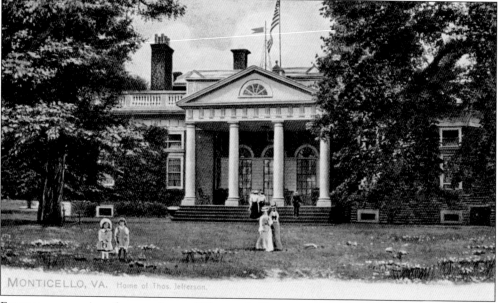

MONTICELLO, VA. Home of Thos. Jefferson.

Everyone recognizes the west front of Thomas Jefferson's Monticello because it appears on the U.S. nickel. This view is of the east front, which Jefferson considered to be the main entrance and is the entrance by which most visitors enter the home. This postcard, produced by Raphael Tuck and Sons, was made in the early 1900s, and the caption reads that the home "commands a view of the Blue Ridge Mountains for 150 miles. Washington, Adams, Lafayette and Hamilton were all entertained" in the home.

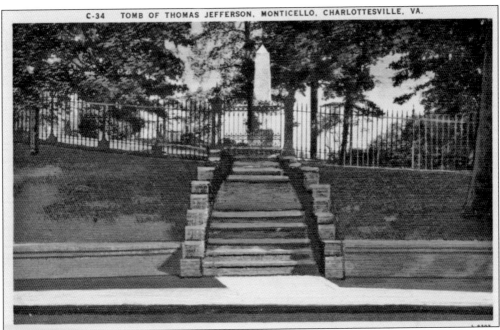

Thomas Jefferson is buried in this cemetery on the grounds of Monticello in Albemarle County. He requested the following inscription for the monument at his tomb: "Here was buried Thomas Jefferson, Author of the Declaration of American Independence, of the Statute for Religious Freedom, and the Father of the University of Virginia." These he considered his greatest achievements, despite his many contributions as president, ambassador, and governor of Virginia.

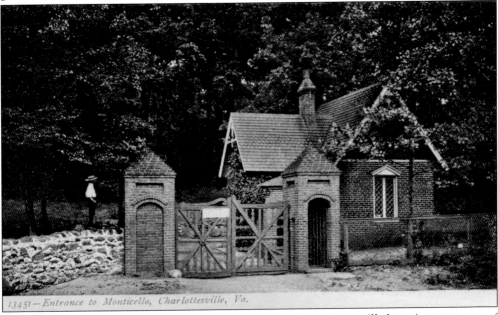

13451—Entrance to Monticello, Charlottesville, Va.

In the early 1900s, a time of few automobiles and with carriages still the primary means of travel, Thomas Jefferson's home, Monticello, was a popular tourist attraction. This would have been a visitor's first view of the entrance to the grand home.

This 1930s postcard, published to benefit the Thomas Jefferson Memorial Foundation and Monticello, identifies this as all that is left of Thomas Jefferson's 1776 gig in which he traveled from Monticello to Philadelphia. A gig was another name for a shay, or one-horse carriage. Shay is the Americanization of the French word *chaise*. This antique's existence calls to mind the opening of the poem "The Deacon's Masterpiece," by Oliver Wendell Holmes: "Have you heard of the wonderful one-hoss shay/ that was built in such a logical way/ it ran a hundred years to a day." Jefferson's "one-hoss shay" had obviously survived equally as long.

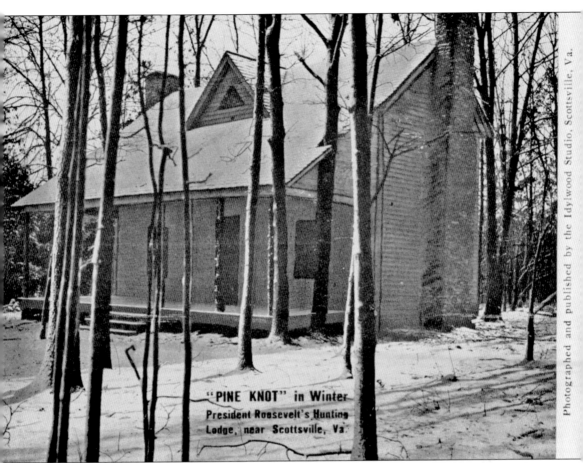

Photographed and published by the Idylwood Studio. Scottsville, Va.

"PINE KNOT" in Winter
President Roosevelt's Hunting
Lodge, near Scottsville, Va.

Pine Knot is listed on the National Register of Historic Places because of its association with former U.S. president Theodore Roosevelt, who stayed here occasionally between 1905 and 1908. A modest structure with few amenities, the Roosevelts' intention was for it to be a place where they could remove themselves from the pressures of the White House and be in the outdoors. According to the nomination form for the National Register, Roosevelt used his time here for outdoor activities, including hunting. Despite it being a time of strict segregation, Teddy would hunt with some of his black neighbors. As one story goes, he once wanted to borrow one of his black neighbor's hunting dogs, but the gentleman refused. When Roosevelt countered by saying he was the president of the United States, the noncomplying gentleman supposedly replied, "I don't give a damn if you're Booker T. Washington; you can't borrow my dogs."

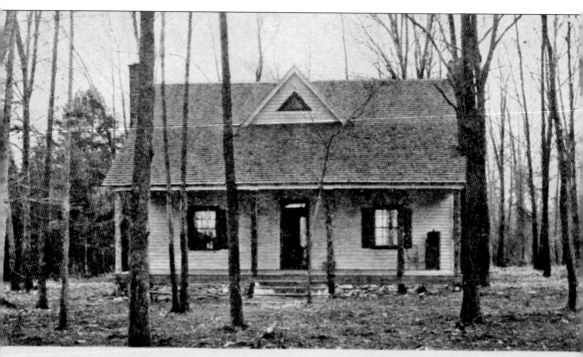

"PINE KNOT," PRESIDENT ROOSEVELT'S COTTAGE, ALBEMARLE CO., VA.—(1)

Of all the U.S. presidents associated with Virgina's Piedmont region, Theodore Roosevelt might be one name that comes as a surprise. A native of New York, Roosevelt's association with Virginia is by way of this humble little cottage in the southern part of Albemarle County. Around 1905, Roosevelt was looking for a chance to escape Washington, D.C. There was no official presidential retreat such as Camp David in the early years of the 20th century, so the Roosevelts purchased this house, known as Pine Knot, located off Route 20 and County Road 712 in the vicinity of Keene. The Roosevelts would take the train most of the way to their destination.